TERRY WINTERS
PRINTS
1982–1998
A CATALOGUE RAISONNÉ

TERRY WINTERS

PRINTS

1982–1998

A CATALOGUE RAISONNÉ

NANCY SOJKA

WITH THE ASSISTANCE OF NANCY WATSON BARR

ESSAY BY RICHARD H. AXSOM

THE DETROIT INSTITUTE OF ARTS

DISTRIBUTED BY HUDSON HILLS PRESS, NEW YORK

This catalogue is published on the occasion of the exhibition
"Prints by Terry Winters: A Retrospective from the Collection of Robert and Susan Sosnick,"
at the Detroit Institute of Arts, September 26, 1998, to February 7, 1999.
The exhibition was organized by the Detroit Institute of Arts
and made possible through the support of Robert and Susan Sosnick,
the Michigan Council for Arts and Cultural Affairs, and the city of Detroit.

Funding for this book was provided by Robert and Susan Sosnick.

Director of Publications: Julia P. Henshaw
Editor: Judith Ruskin
Design: Leslie Miller, The Grenfell Press, New York, with Roland Aeschlimann, Geneva
Typesetting by Katie Michel, The Grenfell Press
Printed by Entreprise d'arts graphiques Jean Genoud S.A., Le Mont-sur-Lausanne, Switzerland

Distributed by Hudson Hills Press, Inc.,
122 East 25th Street, 5th Floor, New York, New York 10010-2936.
Editor and Publisher: Paul Anbinder

Distributed in the United States, its territories and possessions,
and Canada through National Book Network.
Distributed in the United Kingdom, Eire, and Europe through Art Books International.

Library of Congress Cataloging-in-Publication Data
Sojka, Nancy.
 Terry Winters prints: 1982–1998: a catalogue raisonné / by Nancy Sojka; with assistance
from Nancy Watson Barr; essay by Richard H. Axsom.
 p. cm.
 "... published on the occasion of the exhibition 'prints by Terry Winters: a retrospective from
the collection of Robert and Susan Sosnick,' at the Detroit Institute of Arts, September 26,
1998 to February 7, 1999"—
 Includes bibliographical references and index.
 ISBN 0-89558-151-5 (hardback)
 1. Winters, Terry—Catalog raisonné. 2. Winters, Terry—Criticism and interpretation.
3. Sosnick, Robert—Art collections—Catalogs. 4. Sosnick, Susan—Art collections—Catalogs.
5. Prints—private collections—Michigan—Detroit—Catalogs. I. Winters, Terry. II. Barr,
Nancy (Nancy Watson). III. Axsom, Richard H., 1943– . IV. Detroit Institute of Arts. V. Title.
NE539.W57A4 1999
 769.92 – dc21 98-49588

Contents

Foreword
Maurice D. Parrish, Interim Director

The publication of this catalogue raisonné occurs in conjunction with the exhibition "Prints by Terry Winters: A Retrospective from the Collection of Robert and Susan Sosnick" at the Detroit Institute of Arts. Both the exhibition and this book resulted from the collaboration of artist, collector, and museum staff.

The relationship between the Sosnicks and Terry Winters is one of enduring friendship and mutual respect. The Sosnick collection includes Winters's entire print oeuvre as well as many of his paintings and drawings. Winters's work is only part of the Sosnicks' distinguished collection of works in all media by major contemporary artists.

Terry Winters played a vital role in compiling this publication, for which we are grateful. Conducting a comprehensive project dedicated to the work of a major artist is always an interesting experience, but it becomes all the more engaging when the artist participates. Terry's keen insights and contributions to all phases of this undertaking made it a truly rewarding venture for all those involved.

This project began after a visit to the Sosnick collection by Ellen Sharp, curator of graphic arts at the Detroit Institute of Arts. She has provided her expertise throughout its development. Nancy Sojka, associate curator of graphic arts, with the assistance of Nancy Watson Barr, assistant curator, organized the exhibition and compiled the catalogue entries. Judith Ruskin, editor, scrutinized the text and managed the production of this publication skillfully. Kraig Binkowski, associate librarian, was very helpful in securing interlibrary loans.

Thanks are extended to Richard H. Axsom, professor of art history at the University of Michigan — Dearborn for contributing the essay; to Bill Goldston and the staff at Universal Limited Art Editions (ULAE), in particular, Larissa Goldston for confirming and compiling information; to Leslie Miller and Katie Michel at the Grenfell Press, New York, and Roland Aeschlimann in Switzerland for the design of the book; to Hilary Harp in Terry Winters's studio; to Matthew Marks and Leslie Cohan at Matthew Marks Gallery in New York; and special recognition to Hendel Teicher.

Most importantly, it is the Sosnicks' continuing interest and commitment to the vitality of the arts that have made possible this thorough examination of the printed works of a major contemporary artist. We wish to express our deepest gratitude for their ongoing support of the Detroit Institute of Arts. Mr. Sosnick's long-standing commitment to the arts includes his position as an adviser to the Arts Commission of the city of Detroit, his membership on various committees at the DIA, and his standing as a member of the National Committee at the Whitney Museum of American Art in New York. Without Robert and Susan Sosnicks' generous support neither this book nor the related exhibition would have come to fruition.

Figure 1 (facing page). *Boundary*, 1997.
Graphite, ink, and acrylic on paper; 104.8 x 75.6 cm
(41¹/₄ x 29³/₄ in.). Private collection.

Figure 2. *Dark Plant II*, 1982. Charcoal and crayon on
paper; 105.4 x 74.9 cm (41¹/₂ x 29¹/₂ in.).
Collection of the artist.

The Philosophers' Stone: The Prints of Terry Winters
Richard H. Axsom

Since the 1960s, many established American painters and sculptors have made prints an integral part of their art. Their motives have included the conceptual allure of printmaking processes and the joy in refracting ideas through different materials and techniques. For artists like Jasper Johns and Frank Stella, the reciprocities between prints and other media became so intense that to remove the printed body of work from discussion unsteadies the edifice of their art. Some artists made prints before establishing their reputations; others afterward. Some began enthusiastically, or hesitated like Robert Rauschenberg, who, on the eve of making his first lithographs more than a decade into his career, quipped that "the second half of the twentieth century was not a time to start writing on rocks."[1]

Terry Winters undertook printmaking in late 1982, just as the first solo exhibition of his paintings at the Sonnabend Gallery in New York was coming to an end. A serious painter since his graduation from Pratt Institute in 1971, he was presenting new work in the Sonnabend show that signaled a shift in his art. His style had evolved from a painterly minimalism, influenced by Brice Marden and Robert Ryman, to an organic abstraction delineated with references to early biological life. His first prints would reflect this world of forms. But why the decision to make prints at this point and then on a continuous basis over the next sixteen years? First, he felt ready to work in a medium that had attracted him for some time. Second, Bill Goldston's invitation to make prints at Universal Limited Art Editions (ULAE) helped prompt the move, which was further aided by the immediate rapport between the two men. Most importantly, however, was the role of drawing in Winters's art.

Winters is a passionate draftsman (see figs. 1, 2). Drawing is as critical an underpinning of his creativity as it is for such diverse artists as Cy Twombly, Ellsworth Kelly, and Claes Oldenburg. Printmaking is a forum whose procedures and collaborative protocols have allowed Winters to explore the expressive nature of his drawings. For an artist whose cardinal subject is protean form, printmaking encourages a changing image through the various proofing phases that lead to an editioned print. A print reflects a progressive history of alterations. It is a record of mutation, an accumulation of discrete changes that has no exact counterpart in drawing or painting. The technical conventions of printmaking also attract Winters because he can explore the spontaneous gesture, a defining element of his art, within "objective frames and structures."[2]

The printed image, most critically, vivifies the essential poetics of Winters's art: a personal identification of the creating artist with nature. His abstracted, yet allusive images of nature — ranging from crystalline structures to developmental embryology to a more recent preoccupation with abstract architectures — are always things crafted by a creative intelligence; they are not literal illustrations. Printmaking — with its initial composition and subsequent revisions through the stages of proofing, and with the use, alteration, and reuse of stone, plate, or

block — can map out and visualize the creative act as well as the expressive image. The methods of printmaking are for Winters, as for Pablo Picasso and Jasper Johns, a metaphor for the mechanics of creativity.

Winters has always been drawn to the romance of materials and to how nature provides the ingredients with which to make art. In his approach to paintings and drawings, Winters is taken with the historical and geographical resonance of pigments and how they can unleash a sense of organic nature in his art.[3] This is also true for the materials of printmaking: the stone, metal, wood, and linoleum printing surfaces, the inks, and the agents and chemicals with which such elements are prepared to receive a design.

Another aspect of the print that beckons Winters is a historical tie to early printed natural histories. The hand-drawn, illustrated bestiaries, herbals, and astronomical and astrological tracts of antiquity and the Middle Ages were followed during the Renaissance by printed images and annotated texts issued to fill a growing and nearly insatiable appetite for nature. In widely distributed portfolios and bound volumes, the early modern scientist set out to classify the natural world.[4] With increasing precision and scope, a bounty of published materials brought new understandings of European and New World flora and fauna. Winters's art effectively constitutes a natural history, which, in the spirit of systematic documentation, lyricizes the notion of our "knowing the world." His prints, particularly the portfolios with their incorporation of language, elaborate upon the western idea of a natural history, whose aim is to account for the world and arrive at a unified body of knowledge.

Prints hold a central position in Winters's art, co-existing on an equal basis with his paintings and drawings. All three media work in concert. Excluding the drawings and prints would impair a full account of Winters's creativity. A retrospective of Winters's work in 1991 granted impressive space to his prints and drawings alongside the paintings, more so than any recent major exhibition of established artists whose painting or sculpture is enlivened by works on paper.[5] The prints have served as an internal resource that both shapes and is shaped by his art.

When ULAE's Goldston first met Winters and saw his work in late 1982, he noted how critical drawing was to the figurative dimension in the artist's new form of abstraction. Seeing how this element might lend itself to the strengths of lithography, he invited Winters to make prints at ULAE's workshop in West Islip, Long Island, where he was co-principal and manager. Winters was ready. For some time, he had admired the prints Rauschenberg and Johns had done there. Before the year was over, Winters had made his first print. Entitled *Ova*, this lithograph was produced from two stones on which he directly worked and was printed in black ink on mouldmade paper. Conceived as a simple exercise, it initiated a two-year period during

Figure 3. *Morula I,* 1983-84. Lithograph (cat. no. 3).

Figure 4. Pierre-Antoine Poiteau, *Pommier de Montalivet* from *Pomologie Française,* 1846. Hand-colored engraving. Courtesy of Kenyon-Oppenheimer, Inc., Chicago.

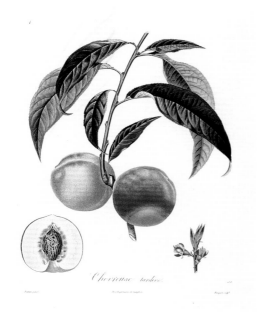

which Winters worked at ULAE one day a week, traveling between his Manhattan studio and the workshop to learn more about lithography. Winters brought this formative period to a close with the completion in 1984 of the three *Morula* prints (figs. 3, 5, 6). These large-scale lithographs demonstrate the artist's early command of the medium and offer tangible evidence that the print could be a significant aspect of his art.

Winters saw these early prints as "my tentative way into finding a place for lithography in the body of work I was trying to build."[6] He was determined to achieve in the prints what he calls "overlapping concerns," an integration of his more figurative drawings into the syntax of abstract painting. His new paintings were already characterized by this methodology. He wanted "a print that did not feel like a print," one which could approximate the materiality of his drawings and paintings. In his second lithograph, *Factors of Increase* (1983), Winters's use of handmade paper facilitated his desire to create prints with "immediacy and physical presence." His choice of a luxuriant Moulin du Verger paper added another element of materiality. As amber is inseparable from the ancient life form it may color and contain, paper would not be a neutral ground for Winters's imagery. Henceforth, the choice of papers would be an important consideration. Adjusting paper to his predominantly subdued palette of earth colors, Winters gravitated toward toned papers, most often off-white, tan, or ivory.

In the *Morula* prints, Winters played upon lithography as a "greasy medium that was easy to load up" as a means of approaching the sensuousness of his drawings and paintings. In place of the oil paint sticks, charcoals, and pastels he used in his drawings, he now substituted thick, fatty crayons. The *Morula* lithographs marked the start of Winters's transferring drawings made on thin papers to stones or plates with solvents or by photo-transfer methods. He then went back into the image as it now rested on a printing matrix with tusche. Using multiple elements for overprinting, he achieved dense, tactile surfaces.

Winters's iconography in the prints, drawings, and paintings of this period, and sustained until the early 1990s, is resolutely organic. Although images of fully matured life forms appear, like mushrooms or a mollusk shell, the majority of living things is drawn from developmental biology, specifically embryogenesis as it embraces the microscopic world of germinating seeds, fungi, algae, and primal animal life forms.[7] Winters's forms in general are not schematic, but easily identifiable. Their displacement from actuality rests in how the artist isolates and disposes them on canvas or paper and in their tactility as sheer medium, be it oil paint, charcoal, or printing inks.

An understanding of Winters's iconography makes apparent that his choice of materials animates it. This is evident when the prints are looked at and handled unframed. The surface of the *Morula* prints is sooty and seemingly tacky with overprinted black and brown inks that make visible the gunky crayon drawings Winters made on the stones and plates. The thick,

Figure 5. *Morula II*, 1983-84. Lithograph (cat. no. 4).

Figure 6. *Morula III*, 1983-84. Lithograph (cat. no. 5).

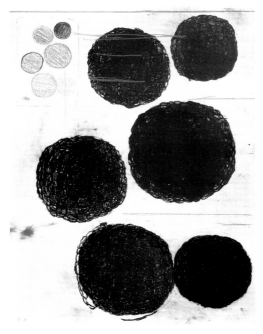

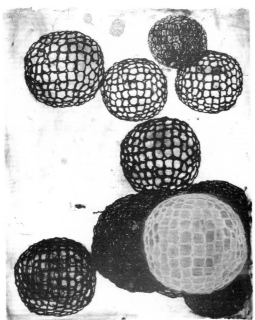

Japanese, handmade Toyoshi paper richly takes the drawing. The scratched lines, the torn edges of the paper, and smudges of black ink that sully the sheet give the prints an aged character in keeping with the early life forms depicted. Preexisting the animal and human worlds by thousands of millennia, these botanical specimens have been situated in deep time. The artist gives us nature in a synthesis of image and medium. He draws attention to the organic qualities of paper and ink to give the *Morula* series an inner vitality that is squarely matched to subject matter. In a synthesis that recalls the abstractions of Jackson Pollock, which greatly influenced Winters, the prints do not simply portray nature; they are of nature.

Winters's morulas are spherical embryonic masses of fertilized ovums. These bundles of cleaving cells formed into blastulas can be scrutinized as though they were botanical plates from some natural history. The impression of specimen is strengthened by the morulas' floating singly and in groups, which would not be the case in nature. Winters, however, does not suspend them flattened on the page but allows them their natural motility and amplitude in an indeterminate space suggested by atmospheric smears and scratched lines printed in varying black inks. Small schematic line drawings in the margin function as analytical annotations for the larger, fully modeled blastulas drawn with thick crayon. These marginalia appear in the outer areas of all three of the *Morula* prints and once in *Ova*. Marginal line drawings were a convention of the illustrated natural history; Pierre-Antoine Poiteau's *Pomologie Française* from 1846 (fig. 4) portrays individual fruits with adjacent visual "notes" of sectioned examples, flower, and seed. Winters integrated this device prominently in his later *Marginalia* (fig. 11), a lithograph whose groupings of multiple embryonic forms and artist's marks along all four sides of the sheet serve as a continuous frame for a flowering shape, itself sectioned to reveal underlying structures.

The marginal notations in the *Morulas* vary in their linear emphasis and content. The marginalia in *Morula I* (fig. 3) include a representational line drawing of a mulberry, setting up a play on word (mulberry is a translation of the Latin *morula*) and image. In *Morula II* (fig. 5), however, the marginal annotation in the upper left-hand corner is a miniature version of the print and its composition of six morulas. Contained within a rectangular frame, the sketchy graphite-like renderings of the morulas appear as an artist's preliminary drawing for a work of art, not a scientific vignette detailing a specimen. These fainter images also suggest pentimenti — exposed underdrawings of a finished work of art.

The morulas have an enigmatic character; if they are bound to the minutiae of nature, they also seem to be airborne celestial spheres. As Winters subtly connects micro- and macroscopic worlds, he also connects himself to both as he, the artist, has visualized them and left his mark. He artificially arranges natural forms, placing them within an implicit grid, especially in *Morula II*, whose sheet is scored by roughly parallel horizontal lines printed in

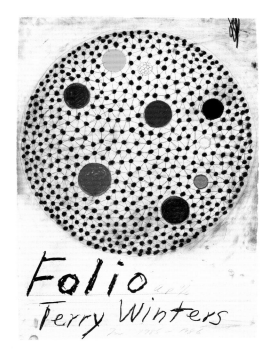

red-brown. The smears of ink in the three lithographs seem to be deliberate wipes on the plates and stones, as though the artist were unloading medium from a brush. Fingerprints appear, even the faint impression of a handprint, as bodily reminders of the artist.

Winters correlates the artist's creative self with a greater scheme of things. In doing so, he revisits the Renaissance notion of the divine nature of artistic creativity. Winters gives metaphorical image to it as nature's generation and regeneration of life. Through the series of three lithographs, the morulas increase in number. Germinating life may be emblematic of the gestation of the work of art, but Winters also wishes to combine the two to picture an intimate relationship between artist's self and nature.

With the *Morula* series of lithographs, Winters begins to put into place a specific identity for his prints. Initially seeking the tangibility of the drawings, which he was able to achieve, Winters nonetheless saw that the prints ultimately were not drawings in how they were made. He distinguishes between his various media according to "degrees of intention" which are related to a "sequence of events": that is, paintings, drawings, and prints each direct him to take different paths in realizing the work of art. A print is an image that may be built up with separate overprintings of color and shape. If the prints are made up of a series of layered drawings, then the printing sequence could be reshuffled and the cumulative effect would shift, both in the style and expressiveness of the image. The print stands apart from a drawing as something that is put together in a series of discrete and potentially permutable actions. Print-making processes tended, for Winters, to fix the spontaneity of the original drawings done in preparation for a print and make the editioned image more distant and indirect—all of which intrigued Winters for the differences wrought on his act of drawing as it migrated to painting and printmaking.

Winters most often works in series. A print, painting, or drawing may stand alone, but usually it can be gathered with others into a group. The *Morula* prints are numbered individually but stand together. Winters shaped his next series, *Folio* (see figs. 7, 8, 9), as a portfolio, whose very format becomes critical to the prints. The extended set of eleven lithographs was placed in sequence in a paper folder, and encased in an ebony box. The majority of prints that Winters has made to date are incorporated into ten portfolios.

Gathering images into a print portfolio — an encased collection of prints — gave Winters the opportunity to experiment with a range of drawing qualities within a single work of art and to explore "lateral relationships" between plates. He extended his idea of the constructed print to a larger entity, the portfolio, which is itself created from a series of images. With *Folio* and future portfolios, he was avidly concerned about "total presentation." He wished to take responsibility for the object as a whole, not only the prints, but the design of the paper folders that would hold them, as well as the casing or box for the folder of prints, the title

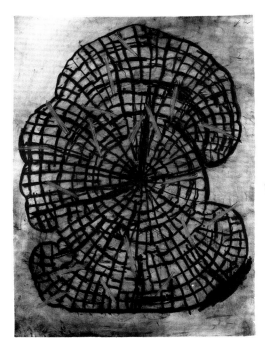

page, and the colophon page, which lists the particulars of artist, printers, publisher, edition size, and assorted proofs.

Folio was prompted in other ways by Winters's use of series in his drawings and paintings and by the precedent of the *Morula* lithographs. Each series has its own autonomy and a "thread" with which Winters occupies himself. He sees a "pictorial narrative" shaping each one. Narrative for Winters need not be linear. Rather, the portfolios are undirected and open-ended, with no apparent goal or proper ending. His "stories" concern change and mutation in nature and in the forms he creates. The portfolios address multiple relationships among things as seen from varying perspectives and can be "read" backward or forward.

The large-scale *Folio*, the title itself evoking an oversized volume, begins its story in nature with the title page (fig. 7). A magnificent volvox, magnified many times over, crowds the page. A multicellular organism, part of a larger phylum of marine and freshwater algae, it is a hollow sphere with hundreds of cells connected by protoplasmic strands. It is a community of cells, with a division of labor between somatic and reproductive functions. Community, indeed, is the thematic drift of the portfolio, a gathering of interdependent life forms like those found in paintings such as *Colony* (fig. 10). Growth and change seem directed toward a greater collaboration of forms. Single entities that appear in *Folio One* through *Folio Three* — an open skeletal-like shape, a blastula, and a median section of an embryo (fig. 8) — are followed in *Folio Four* through *Folio Nine* by increasingly more life forms. Deep earth colors of black, browns, and rust-reds dominate these pages. Winters had tried graphite inks to match the graphites of his drawings but, dissatisfied, settled on a combination of silver and black inks. The effect is arresting; organic forms are frosted with opalescent sheens of light. Then, *Folio Seven* and *Folio Nine* break out in unexpected color. *Folio Nine* (fig. 9), the last image, is the most complex in its printing, its colors, and in the gathering of disparate forms to create a multiplicity that seems a fitting cap to the progression of forms throughout the portfolio. From the sobriety of *Folio One* to the whimsical disporting of forms in *Folio Nine*, there is a current of mood shifts and increasing intricacy that pulls the viewer through the portfolio. If narrative is suggested, questions still remain about the exact nature of the many connections that can exist between the pages and their resident forms.

Folio carries Winters's own stamp in image and in language. In the portfolio, he wished to pull from the medium all that lithography could give in the way of registering an image. It became "a chart of every kind of mark" — those made by a wide variety of pens, pencils, and crayons on plates. But *Folio* also includes language, which becomes increasingly significant in later editions. The title page and colophon page of *Folio* reveal Winters's own handwriting. He names the portfolio and himself as artist, and gives the details of production and publication on the colophon page. Winters sought to establish relationships between these

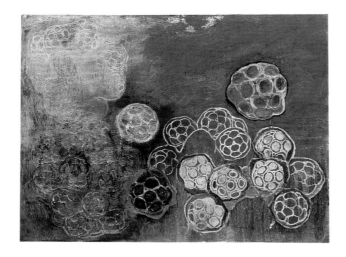

Figure 10. *Colony*, 1983. Oil on linen; 194.4 x 262.9 cm (78¹/₂ x 103¹/₂ in.). Private collection.

pages and the imagery of the other sheets. Be it text or image, both are autographic forms. Winters also feels that language here "reiterates intentions and the deliberateness of imagery." His hand-printed text further personalizes the portfolio.

As he had before, Winters wedded the processes of biological life to the processes of making art itself. At the top of *Folio Eight*, Winters crayoned in the word "top," suggesting, as a working proof might, the proper orientation of the image. In *Folio Nine*, a printed image of a small, ripped-off sheet of spiral notebook paper looks like a preliminary sketch. It appears adjacent to a yellow vertical rectangle that contains its own doodled forms. As these two images rest on the larger sheet with its own set of shapes, *Folio Nine* looks like an artist's drawing board of ideas, or a working proof with the artist's directions to the printers for the next step in a print's resolution.

It is Winters's particular use of color in the title and colophon pages that makes it clear that we are not looking at representations of nature but at a metaphor joining human creativity and embryogenesis. Eight large cells in the volvox sphere of the title page are prominently inked in color. The color disks are black, white, the primaries (red, yellow, blue), and the secondaries (orange, green, purple): the primal building blocks of color. The title sheet is for all matters a Genesis page in every sense of the word. In *Folio Four*, three small disks of red, yellow, and blue hover at the top of the sheet, reminding us of the basic underlying elements for what we see created. On the colophon page, Winters also gives us the recipe for the inks he has used in the production of the portfolio, listing his ingredients in separate vertical smears of the twenty-three colors he has used. They look like the "pulldowns" of inks that a printer might make with a palette knife on a glass surface prior to mixing inks or charging a brayer with inks to roll across the lithographic stone or plate.

Folio was a culminating point for Winters's engagement with lithography. In little over two years, under Bill Goldston's guidance, he had come to make lithography his own. He deftly controlled the complexity that arose from multiple layerings of thickly printed forms, the use and reuse of a greater number of stones and plates (up to forty-one), and an increased play of color in a single print. Offset lithography, which had figured in earlier prints for the convenience of dropping in the schematic marginalia, now was his process of choice for all of the prints in *Folio*. Winters appreciated the fidelity of the offset image to the original drawing he made on the plate. The drawing was not reversed as when printed by direct lithography, and the ease of registration facilitated the exploration of overprinting. Offset printing was also direct and immediate, providing a means of getting back to the image quickly after proofing, making decisions, and moving on with new solutions. Winters collaborated with ULAE printer Keith Brintzenhofe in a small, private space away from the workshop, where they sometimes worked four days a week for many weeks to create *Folio*.

Figure 11. *Marginalia*, 1988. Lithograph (cat. no. 32).

Figure 12 (facing page). *Dystopia,* 1985. Oil on linen; 203.2 x 142.2 cm (80 x 56 in.). Collection of the artist.

Winters carried no preconceived notions of where the *Folio* project might lead him. He has said in regard to his printmaking that "work is driven by collaborating with circumstance." Those circumstances include where he is making the print, with whom, and the materials and processes at hand. There was good grist for his mill in making *Folio*: the exclusive use of off-set lithography, experimentation with multiple plates and overprintings, the reclusive and intimate collaboration with Brintzenhofe, a sole preoccupation with the project (he painted very little during the period), and the ambitiousness of undertaking an extended series and coordinating eleven prints into a coherent portfolio. Work on *Folio* was intense. When he finished the project, the character of *Folio* immediately spilled over into the paintings, establishing the first instance of what he describes as "cross-breeding" between prints and paintings. He originates all of his ideas in drawings. The many plates he created for *Folio* confined his drawing during this period to preparations for prints rather than to finished, original drawings. Given the energies Winters put into the drawings for *Folio*, he was not surprised to see an immediate impact on the paintings, specifically *Dystopia* (fig. 12), the first instance of prints bearing directly upon what he would do in paint. In this case, *Dystopia* existed first as one of several drawings made for *Folio,* but was ultimately not included in the portfolio.

Although he would intermittently make lithographs with ULAE in the years to come, he undertook no other major portfolio project in this medium. In 1988, he turned his immediate curiosity elsewhere. When Goldston encouraged Winters to test intaglio media at ULAE, he began work with John Lund on *Station*. Its centered flowerlike image was taken from *Marginalia* (fig. 11), whose contour drawing of the subject he now reworked in the tonal washes characteristic of aquatint. Winters also started work in Paris with Aldo Crommelynck, Picasso's last master printer, who gave Winters an extensive introduction to etching in his atelier. The collaboration, the first away from ULAE, resulted in *Album*, a portfolio published in 1988 by Editions Ilene Kurtz. It consisted of nine etchings, including Winters's own realizations of title and colophon pages. Over the next four years, Winters would produce two other ambitious portfolios with intaglio media: *Fourteen Etchings* (1989) at ULAE and *Field Notes* (1992) with Crommelynck, who this time both printed and published the project.

To make *Album*, Winters traveled to Paris four times over a period of a year for two-to-three week working sessions. Exposed to Crommelynck's rigorous methods, Winters felt he was receiving intensive training. But he took to the new shop environment with great interest. Crommenlynck was for Winters the consummate master craftsman, redolent of the history of the early modern print for having collaborated with many of the most important artists of the twentieth century. Shop procedures were classical and fastidiously controlled by Crommelynck, who had exacting ideas about printing processes. Winters was challenged by the new information he absorbed in the atmosphere of the shop. The meticulous protocols served as yet another

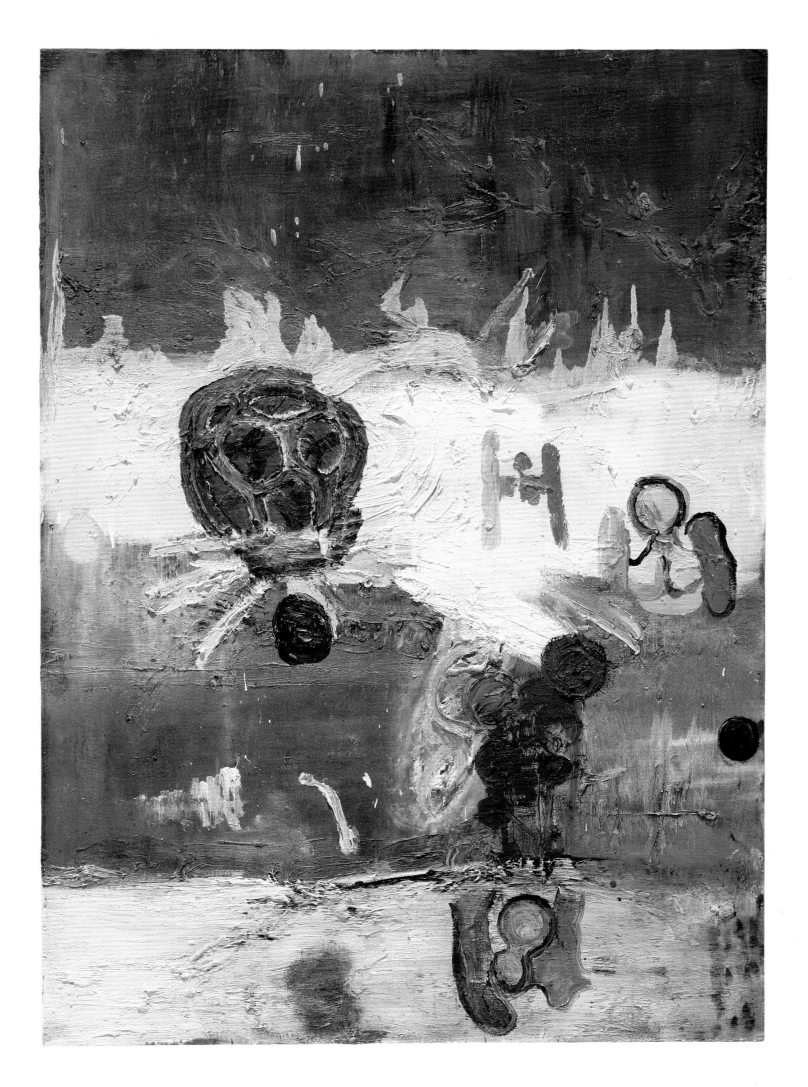

19

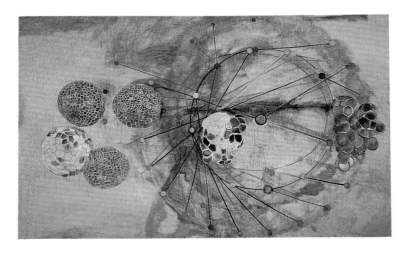

Figure 13. *Eureka*, 1989. Oil on linen; 243.8 x 396 cm (96 x 156 in.). Collection of Fukuoka City Bank, Ltd., Japan.

objective structure within the traditions of printmaking against which to pit the inherent spontaneity of his visual imagination. More formal than the setting at ULAE, Crommelynck's workshop was, however, no less willing to experiment. Winters was attracted by his isolation in Paris for what was necessarily a project controlled by time and logistics. Things had to get done. ULAE, an hour's train ride from Manhattan, was an extension of Winters's studio. There was no pressure to complete work in a single session. The two shops had very different feels for him. He saw how the nature of each affected the prints he made. For Winters, "the printer is another component, a 'resist' [a pun on the printer's word for a stop-out solution in intaglio printing] and an assist," playing a critical role in facilitating the artist's vision.

With the various types of aquatint printing, including spit bite and sugar lift, Winters worked freely with a brush. He produced highly nuanced ink washes, which took on the qualities of watercolor, the medium that aquatint printing was developed to emulate in the eighteenth century. Although using some soft and hard ground etching with which to establish line, the prints of *Album* and *Field Notes* are essentially mixtures of aquatinting processes. *Field Notes* was as much an inventory of possible marks made with etching's processes as *Folio* was for lithography. Winters applied acid directly to the copper plates for open biting and scraped plates to remove stop-out varnishes and etched areas to begin again, leaving ghost traces that would still accept ink. Although a draftsman, his line is painterly, and he has yet to work with traditional engraving techniques.

In 1989 Winters explored new technical ground in his portfolio *Fourteen Etchings* (see figs. 14,15). He selected eleven photographic illustrations from a late nineteenth-century German book on anatomy and had them made into photogravures for the portfolio. The illustrations were X-rays of human skeletons that isolated skull, rib cage, collar bone, shoulder joints, elbow, hand, foot, and leg bone. With the exception of the first image, two plates were used to create each print. On each sheet, a photogravure of an anatomical part was printed toward the lower right-hand corner. In the upper center, Winters affixed a separately printed sheet as a *chine collé* element. It carried an abstract image that he originally drew on Mylar and was then transferred to a copper plate and aquatinted. The resulting upper images reprise the volvox sphere from *Folio* but are compounded by other analogous forms that are floral, diagrammatic, or crystalline in appearance. Winters saw the Mylar drawings as being resolved in their own right as works of art and showed them, along with the portfolio *Fourteen Etchings*, in an exhibition.[8] This is a paradigmatic instance of Winters's "cross-breeding" between media, an exchange in this instance between drawing and prints, where drawings for printing elements are simultaneously viewed as independent entities.

A literary dimension, more pronounced than in earlier work, surrounds *Fourteen Etchings*. Fond of Edgar Allan Poe, Winters had originally planned to illustrate Poe's *Eureka*, an

Figure 14. *Fourteen Etchings 2*, 1989. Hand-drawn Mylar gravure, spit bite aquatint, and photogravure (cat. no. 35).

Figure 15. *Fourteen Etchings 6*, 1989. Hand-drawn Mylar gravure, sugar lift aquatint, and photogravure (cat. no. 39).

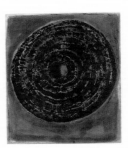

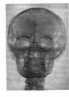

ambiguous prose poem that describes the universe, simultaneously mocking and mystifying nineteenth-century scientific certainties.[9] But, after finding the book of X-rays and being intrigued by his discovery of a list of major constellations in the fourth edition of *Roget's International Thesaurus*, he reshaped the project, jettisoning the specific illustrating of Poe, yet remaining near in spirit to the author's words. Winters placed the entire set of prints in a handmade five-page paper folder, which includes the title and colophon. An alphabetical list of constellations in Latin and English appears on the inner cover. Although Winters had introduced handwritten words in *Folio*, his incorporation of a selected, readymade "text" in *Fourteen Etchings* was an effort to establish a more fully realized literary component that paralleled the imagery.

With X-rays and drawings set for comparison on each sheet, we see oppositional pairs — figurative/abstract, human/non-human, macrocosm/microcosm. The mind and eye, however, intuit similarities when, for example, circular forms echo each other or when skeletal fragments seem abstract. The volvox shares its identity with concentric circles, suggestions of celestial globes, and diagrammed planetary orbits. These associations are encouraged by the printed list of star forms, which, in its suggestiveness, does not stand apart from the images. The atomized spray of ink dots in the drawings for *Fourteen Etchings 6* (fig. 15), for example, could be a swarm of infinitely small organic life, or a star map. The two sets of images and Roget's list make allusions to three realities: the microscopic, human, and astronomical. Yet their images in the prints give us what the naked eye cannot see, what lies beyond immediate unaided perception. Much as the X-ray makes visible the invisible, so does Winters as he hints at the secret affinities among all things. After completing the small-scaled *Fourteen Etchings*, Winters wanted to import his ideas to a large painting. The result was *Eureka* (fig. 13), whose title acknowledges his original source for the print portfolio.

As was the case for the earlier series and portfolios — the *Morula* prints and *Folio* — Winters's intaglio projects of the late 1980s and early 1990s are forms of natural histories. *Album* is just that, a collection of portraits of related spherical shapes. The volvox appears on the title page and in a later sheet. Blastulas and other forms of cleaving-cell embryos pose singularly and in groups. The burnished, lithographic atmospheres of the *Morula* series and *Folio* are now replaced by more liquid environments in which forms float, suspended in Winters's gently brushed aquatintings of the copper plate. In *Album 2*, eleven cell colonies bob and turn in an aqueous setting. Their ambiguous movements and spatial position are put into play with a full complement of soft ground etching and spit bite and sugar lift aquatint. *Album's* palette, in contrast to *Folio's*, is a darkly rich range of blacks, tans, and slate grays, which give it a graver cast not dissimilar to *Fourteen Etchings*.

Winters brought a free-ranging improvisation to the twenty-five etchings of *Field Notes* in a virtuoso play with intaglio techniques, printing each image in black ink from a single plate.

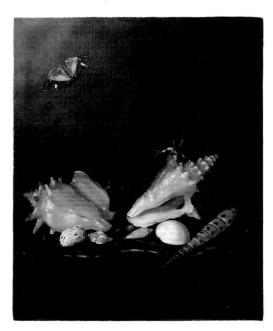

Figure 16. Pieter van de Venne, *Still Life with Shells and Insects*, 1656. Oil on wood panel; 25.6 x 20 cm (10 x 7⁷/₈ in.). The Detroit Institute of Arts, Founders Society Purchase, General Membership Fund (39.671).

Spontaneity led to forms opening up, becoming more invented in appearance, less literal in references to specific organic life. Created after his retrospective exhibition appeared at the Whitney Museum of American Art in 1992, they reflect a shift occurring in Winters's iconography, which according to the artist was a deliberate "pushing of the image to places not reducible to a single reading." Yet *Field Notes* still brandishes the dualism that distinguishes the earlier work: the affiliation of the image with both nature and the artist's creativity. The title of the portfolio reflects this duality. The "field" of an artist's image, particularly in abstract modernist painting, is the entire area of the canvas to be worked evenly for variety and formal tensions. The twenty-five etchings in question exhibit themselves as preliminary sketches, quickly executed to serve as "notes" for what will be a fictive finished work of art. On the other hand, Winters's etchings are also notes made from nature and taken from his "fieldwork," his meditations on the order of things.

The printed natural histories of the Renaissance and later were classifications and systematic orderings of flora and fauna. Alchemical, astrological, and astronomical treatises also contributed to a developing science of systematics. When taken together with natural histories, so philosophers thought, these volumes could provide a new understanding of existence and a modern *summa,* or synthesis, of all human knowledge. Leonardo's annotated drawings of the natural world, its denizens, and human anatomy initiated the quest for a reasoned understanding of the world through observation. Printed natural histories begin to appear in the late sixteenth century, and many print collectors aspired to create a collection of images, drawn from biblical, mythological, and empirical observation, that would constitute an encyclopedic account of their world. Middle-class Dutch and Flemish collectors in the seventeenth century set up *kunstkammers* in their homes, intimately scaled rooms for displaying a private collection of prints, paintings, sculptures, and exotica that would represent the full range of human and divine creation (see fig. 16).[10]

On a far grander scale, the philosophes of the Enlightenment introduced their rationalist account of all knowledge with the publication of Diderot's *Encyclopédie.* Winters is aware of the history of natural histories, particularly those of the nineteenth century, which could also include photographic documentation. He admires the American naturalist and artist John James Audubon, who in his *Birds of America* (1826-1838) defined for Winters "a project with a clear objective — he invented incredible pictures within very defined structures." Audubon set parameters on his project: all the birds of North America, life-size, shown in typical behaviors in their natural habitats (see fig.17). Within these strictures, Audubon, like Winters who also sets to work within controlled guidelines, lets his imagination go. In these historical summaries of human knowledge, Winters sees "presentations of facts" that create systems of propositions about the world. He sees the "folio idea" as an "expansion out of a single image into a larger matrix of propositions."

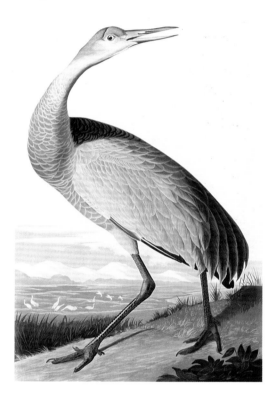

Figure 17. John James Audubon, *Whooping Crane, Young* from *Birds of America,* 1826-38. Hand-colored engraving. Courtesy of Kenyon-Oppenheimer, Inc., Chicago.

Of all the portfolios, *Fourteen Etchings* comes across most trenchantly as a latter-day *summa*, a millennial reflection on who we are and what we are. The traditional composition for illustrations in natural histories was the specimen isolated against an empty ground, typed, and made to assume a place in Plato's "great chain of being": from the simplest forms of life to full humanity. In Winters's portfolio, three levels are brought together in the spirit of analytical classification and comparison. We move from the microscopic to the human to the celestial, the first two presented by images on the sheet, the last reinforced by Winters's selected text. As expected, his propositions take the form of a figurative, not literal, visual language; and they are ambivalent. If all phenomena are interconnected in some philosophical oneness as suggested by *Fourteen Etchings*, a brooding tone remains in the dark cast of the images. Moreover, the human skull, if registering as memento mori, raises existential doubts about any consoling significance of a greater scheme of things. The portfolio may ponder Pascal's fear of the "eternal silence of…infinite spaces."[11]

In the same year he fashioned *Fourteen Etchings*, Winters began a portfolio of woodcuts, his first experience with relief printing. Entitled *Furrows* (1989), it did not come about because he self-consciously wanted to explore new media. Nor for the same reason did two subsequent portfolios appear, produced with other processes he had not yet essayed: screenprinting in *Primitive Segments* (1991) and linoleum cutting in *Glyphs* (1995). Contingencies, which can involve printers, settings, and things that come his way, as much as materials and process, drive Winters's art, leading to what the artist calls "circumstantial invention."

In 1989, while Winters was in Tokyo for an exhibition of his paintings, the celebrated Japanese screenprinter Hiroshi Kawanishi, who would later collaborate with the artist on *Primitive Segments*, introduced him to a special category of woodworking tools used to cut commercial signs. Drawn to the beauty of their design and to their unusual blade angles and shaped wood handles, Winters acquired a set for himself, although he had nothing particular in mind for them. Shortly afterward, the New York publisher Peter Blum asked him to do a project. Peter Blum Editions specialized in portfolios and book formats, and Winters had admired woodcut portfolios by Francesco Clemente and A. R. Penck that Blum had published. Winters made the decision to create woodcuts for a portfolio, produced in Switzerland with master printer François Lafranca. His decision was based not only on his periodic travels there and the reputation of the printer, but also on the availability of many varieties of timber at Lafranca's mountaintop millshop. With his Japanese tools, Winters set to work on what would become *Furrows*, a group of five woodcuts (see fig. 18).

Winters wanted to make prints that would not be immediately seen as woodcuts. He brought with him a transparent black etching ink with which to print, foregoing the usual relief printing inks. He used two blocks for the printing, choosing oak for the first element, which was

Figure 18. *Furrows IV*, 1989. Woodcut (cat. no. 52).

Figure 19. *Primitive Segments, V*, 1991. Screenprint (cat. no. 63).

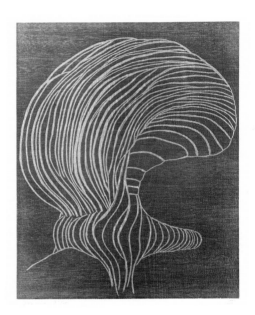

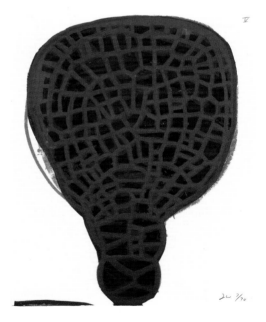

printed as a flat surface with no design, registering only the vertical grain of the wood. It was overprinted with a denser mahogany block into which Winters cut his line drawings across the wood's horizontal grain. His method is more akin to intaglio procedures, which is suggested by the unconventional reference to "blocks engraved and proofed" that appears on the colophon page of the portfolio. Winters reversed the traditional woodcut process of cutting away the background to allow the design to remain in relief, which is then inked and printed. The line drawings in *Furrows* received their inked color, a transparent black, from the first printed oak block.

Winters derived the splayed, flattened forms in the drawings from median brain sections. He had just returned from Japan, and the drawings further reminded him of furrowed Zen gardens. They were also suggestive in title and image of agricultural fields. Winters's *Furrows*, however, were not cuts in the soil, but in wood, an organic substance whose grain Winters saw as "unique to the growing process." The final images were prints that "evolved out of the process of their own making," both nature's and the artist's. The methods that brought *Furrows* into being were suggested by its three-page folder, of which the title page is printed from an unscored mahogany block with horizontal grain, an inner cover printed from an unscored oak block with vertical grain, and the colophon page printed with both blocks. Like the primaries and secondaries he used in *Folio* to declare the basic units of color, Winters's oak and mahogany planks are printed on the pages of the folder to declare the literal building blocks of this portfolio.

Special circumstances again surrounded Winters's moves into other processes and triggered the creation of the portfolios *Primitive Segments* (see fig. 19) and *Glyphs* (see fig. 20). Wishing to produce a screenprint portfolio with master printer Hiroshi Kawanishi himself, Winters worked in Tokyo on *Primitive Segments* in 1991. The five screenprints with title page and colophon were published in New York by Simca Print Artists and the artist. *Glyphs* came about because Winters had talked for years to Leslie Miller, a graphic designer and printer in New York, about doing a project for her Grenfell Press. He wanted to make something that was specific to her studio and the amount of letterpress printing produced there. With great respect for Pablo Picasso's linoleum cuts and a wish to entertain fresh materials, Winters set about working in the relief medium that the Spanish master reinvented in the 1950s. He also liked the touch and smell of linoleum, a material resonant with childhood memories — it was much used in his father's construction business.

The processes by which the two portfolios were made followed standard practice only to a point. As he had inverted the traditional methods of woodblock printing, he was also eager to play with the practices of screenprinting and to respond to Picasso's handling of the linoleum cut. Winters's desire to create as tactile a screenprint as possible led to the unorthodox

Figure 20. *Glyphs, 1,* 1995. Linoleum cut (cat. no. 110).

use in *Primitive Segments* of three encaustic inks: beeswax blended, respectively, with charcoal, graphite, and zinc white. Winters worked each screen directly, painting the image with tusche. The printers would then stop-out the remaining surface, allowing the inks to "drop"and form the design on the paper below. Kawanishi melted the encaustic media, mutating it into liquid form, which he then had to squeegee quickly through the screens before it congealed. Winters used multiple printings of the three inks to create complex interweavings of layered color. In *Primitive Segments, V* (fig. 19), for example, two layers of graphite are followed by one of zinc white, one of graphite, one of charcoal, and five of graphite. The sensual and raw forms rise, like dense geological strata, on Winters's selection of a coarse Echizen-Kisuki-Hosho handmade paper.

For the making of *Glyphs*, Winters was drawn to the way Picasso had taken the linoleum cut, which was produced with the simplest of printing methods, and reworked it with the utmost sophistication. Winters admired Picasso's *épreuves rincées*: linocuts that the artist "rinsed" while making.[12] After cutting away the designs in his linoleum block, Winters had it rolled with a black oil-based ink that would, importantly, repel water in the next printing step. Fascinated by indigo and its history as a dye, he took this allusive pigment and then used it to flush the black-printed sheets — rinsing them as Picasso had his linocuts. The black grounds shed the water-based indigo, but the open areas of unprinted paper — the shapes themselves — eagerly soaked up the dye. Like the line drawings of *Furrows*, the skeins of line in *Glyphs*, cut out of the linoleum blocks, remain uninked. The indigo sheet stains them with radiant color. Rather than simply dye the paper and overprint it with the image, Winters reversed the process because he wanted to emphasize the physical act of rinsing the paper and the centrality of the indigo to the drawn forms, which are Winters's subjects. The process furthermore directed the nature of the image by giving contours an electric edge as indigo dye met, nearly met, or overlapped black-ink edges.

Both *Glyphs* and *Primitive Segments* signal an important stylistic and expressive change occurring in Winters's art. As he revised and elaborated upon his earlier vocabularies of botanical forms, new shapes began to crowd the page. Spheres and ovoids opened into extended patterns, often with honeycombed interiors, suggesting irregular grid geometries. Subtle net-like configurations had appeared in the 1980s in *Folio, Novalis,* and elsewhere, but now they were the basis for a new synthesis combining organic and technological forms. This move, accompanied by an intense use of color, which was new to his printmaking, is dramatically seen in *Models for Synthetic Pictures* (1994), a portfolio that also demonstrated the artist's continuing engagement with etching (see fig. 21).

Returning to soft ground etching for drafting forms coupled with spit bite and sugar lift aquatints for tonal washes of color, Winters adopted open bite etching for additional linework. He

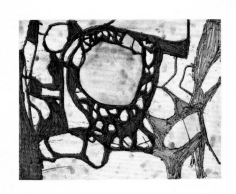

Figure 21. *Models for Synthetic Pictures, 1*, 1994. Open bite etching, soft ground etching, sugar lift aquatint, and spit bite aquatint (cat. no. 97).

had worked with this technique earlier in an untitled etching he did on the occasion of his retrospective exhibition in the early 1990s. For *Models*, he drew with crayon or lacquer pen directly on the plates. The drawn forms were resistant to acid and remained in relief as unprotected areas were eaten away. When the plate was wiped with ink, these forms were left relatively free of medium and printed as negative shapes, like the forms of *Furrows* and *Glyphs*, taking their color from the paper or aquatinted grounds.

The twelve etchings of *Models* are characterized by bravura drawing of open skeins of lines suffused with rich color. Forms are distributed fairly evenly across the sheet in all-over compositions that contrast with Winters's earlier images of discrete shapes isolated on the page. Images are also more resolutely abstracted and less representational or referential. The systems of line balance spontaneity and a sense of structured design. The strong colors are startling in contrast to the range of muted earth colors of earlier prints. Winters's interest in more fully exploring the color range of his paintings in his prints begins to appear with *Theorem* (1992) and *Locus* (1993), two lithographs he did at ULAE. Yet we are unprepared for the burst of saturated color that Winters displays in *Models* using only three colors — the primaries red, yellow, and blue — and black. When other colors appear, they are the results of overprinted primary colors. The artist's keeping with only the primary colors in *Models* is reminiscent of how color played a role in *Folio* as a sign of artistic process. The three-page folder in which the etchings are placed reinforces this expressive dynamic. The background of the title page is printed a solid blue, an inner cover in red, and the colophon in yellow.

The "synthetic pictures" referred to in the title of the portfolio suggest the nature of Winters's new iconography, a synthesis of the organic and the technological. The organic remains visible in shapes that seem capable of growth and in the exuberant vitality of drawing. Ironically, the inorganic is alluded to by the same drawing, which also evokes circuitry and charts. The sheen of the inks and the open bite passages recall both crystalline and metallic structures and add resonance to what Winters calls "constructions of non-organic life."

More specific ties to worlds of human meaning are found in the text Winters created for *Models* and which appears printed in black type on the inside of the folder's red cover. Using the language of computer visualization and mathematical analysis, Winters puts forward twelve axioms and propositions about drawing, painting, and "pictures." Winters restates the shared identity of nature's and the artist's processes, adding to his equation the technical and cerebral realm of human knowledge. This is articulated by a figurative language that postulates a "genetics" of pictures to be found in systems, light, space, and surface. Here are notions of "drawing stored as an abstract" and "mapped projections" of images. Winters sees his work at this point as becoming more abstract yet still specific. He sees his activity as "descriptive and referential — it's a pragmatic picture making based on coincidences rather than idealizations."

Figure 22. *Anagram of Connections* from *Ocular Proofs,* 1995. Ink on paper; 21 x 14 cm (8¼ x 5½ in.). Collection of the artist.

Figure 23. *Ocular Proofs,* cover, 1995. Offset lithography; 21 x 14 cm (8¼ x 5½ in.). Collection of the artist.

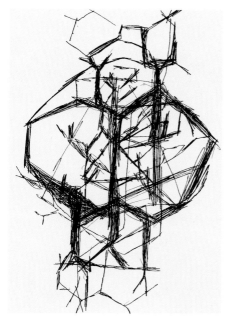

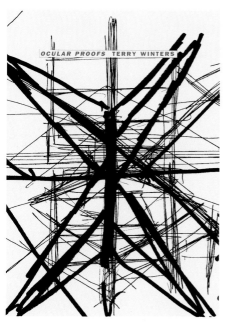

Earlier in the decade, in reference to the new course his painting was taking and which would soon be reflected in the prints, Winters stated his expressive interests: "I like the way graphs, charts, maps, and blueprints look — the way they are set up as pictures that describe the way the world is, or how something works. In my paintings I try to set something up that seems to be about factual description but really isn't."[13] Winters's love of language that documents the world and creates knowledge is joined to *Models* with "a visual language that would not inhibit or overdetermine the abstract image."

The formative role that Winters's drawings play in relationship to his paintings is assigned to the etchings of *Models,* which are themselves delivered as propositions for "pictures." In the drawings, a pivotal series for this purpose was *Schema,* a group of seventy-five mixed media drawings that Winters made between 1985 and 1986. Here was a primer, a repository of new ideas, to be developed in the paintings. Ten years later, during 1995-96, Winters produced two extended sets of drawings, one accompanied by written texts, which unleashed a prodigious flow of ideas and related paintings and prints that continues to the present.

In *Ocular Proofs,* an artist's book created in collaboration with Leslie Miller and published by the Grenfell Press in 1995, forty-seven poetic stanzas, unpunctuated with the exception of slashes, are paired with reproductions of black-ink drawings (see figs. 22, 23).[14] Pairs of text and image carry as titles elements of artistic forms (*Light, Space, Tone*), mathematical terms (*Vector, Rotation, Algorithm, Distribution Functions*), and enigmatic phrases (*Surrounded by a Condensation of Marks, Anagram of Connections*). *Ocular Proofs,* like the text page for *Models,* is a compilation of poetic propositions about making art. Winters's written statements, articulated as mandates, address both the relationship of painting and drawing and the nature of human intelligence that apprehends the physical world in symbolic terms. Winters would appropriate titles of stanzas from *Ocular Proofs* for prints and paintings affiliated with the second group of black-ink drawings, *Computation of Chains.*

Comprising 125 drawings, *Computation of Chains* was an outpouring of invention during a six-month period between mid-1995 and early 1996. Winters never had any idea where the original set would lead him. Over the next two years, however, he found himself responding to the drawings in the creation of three print series (two in etching media, one in woodcut), individual prints, a set of etchings for an artist's book done in collaboration with a Swiss literary critic, and two painting series. All of this work is related by intricate reciprocities between media that identify this as one of Winters's most fecund periods.

A comparison of the painting and print entitled *Picture Cell,* both of which Winters derived from *Computation of Chains,* discloses how the expressive character of an image shifts when the artist proceeds from a drawing to other media. Yet taken together as emanating from a single

Figure 24. *Computation of Chains, 125,* 1995-96.
Ink on paper; 21 x 29.5 cm (8½ x 11⅝ in.).
Collection of the artist.

Figure 25. *Picture Cell,* 1997. Etching and sugar lift
aquatint (cat. no. 120).

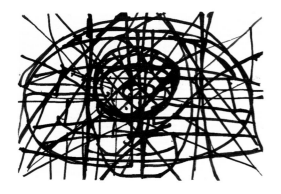

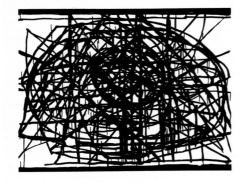

idea, *Picture Cell,* as it exists as a drawing (*Computation of Chains, 125,* fig. 24), a painting (fig. 26), and a print (fig. 25) in a fluid sequence of developing mutations, has a collective expressive power.

At more than six feet by eight feet, the painting *Picture Cell* allows the eye to look about and explore the many ambiguities of line resulting from the infusion of color into the black-ink schema of the related drawing and from the way Winters insinuates color into color with oil and alkyd-resin media. He also weaves his linear designs into elusive colored grounds that come into being from a subtle thickening of line itself. The play between the denser ground forms and the more open skein of linework creates distinctive tensions in the painting in contrast to the original drawing. Complicating this relationship is the unfixed spatial position of the linear system, induced in part by the colors from the grounds that Winters brings forward to variously push and bleed into line. This aggravates any attempt to read the image as a simple, static layering of grid, ellipse, and diagonal. By braiding these elements together, Winters propels everything into great movement. Remarkably, he holds tight the surface with line while admitting depth through change of color. He relishes the power of color, the associations made with it, and its unpredictable qualities. Color, as it gives *Picture Cell* its own expressive identity in a range of pale blues and whites punctuated by flashes of black, red, and yellow, further suggests Winters's wish to use color "to describe degrees of activity, the temperature of gestures."[15]

The print *Picture Cell* (1997) is one of five etchings affiliated by medium, scale, and the fact that each was printed from a single plate. The group includes *Systems Diagram, Developmental Surface Model, Face Boundary,* and *Internal and External Values,* which were also all drawn from *Computation of Chains.* Linework in the prints, like in related paintings, is brushed, in this instance onto copper plates with sugar lift and spit bite solutions. In an unusual move, printer Craig Zammiello at ULAE did not aquatint the exposed copper drawing with conventional means. Instead, he airbrushed a fine spray of stop-out directly on the plate. *Picture Cell,* a sugar lift aquatint, seems to duplicate the even ink density and the black-and-white contrasts of its related drawing. However, Winters edits line by adding, connecting, and eliding to rework the drawing. He does not draw line so much as to brush it and swell it, placing the image between the transparency of the drawing and the density of the painting. He also brushes broad borders at the top and bottom of the sheet. Coupled with its large scale (forty-two inches by fifty inches), the print is given an authority not found in the drawing but seen in the large, related painting.

Four of the etchings in the group, including *Picture Cell,* are printed with black ink; the fifth, *Internal and External Values,* with Prussian Blue. Resolved later than the other four, this print also realized the intricate overlaying of line seen in the paintings related to the *Computation*

Figure 26. *Picture Cell*, 1997. Oil on linen; 193 x 251.5 cm (76 x 99 in.).
Collection of Dean Valentine and Amy Adelson, Los Angeles.

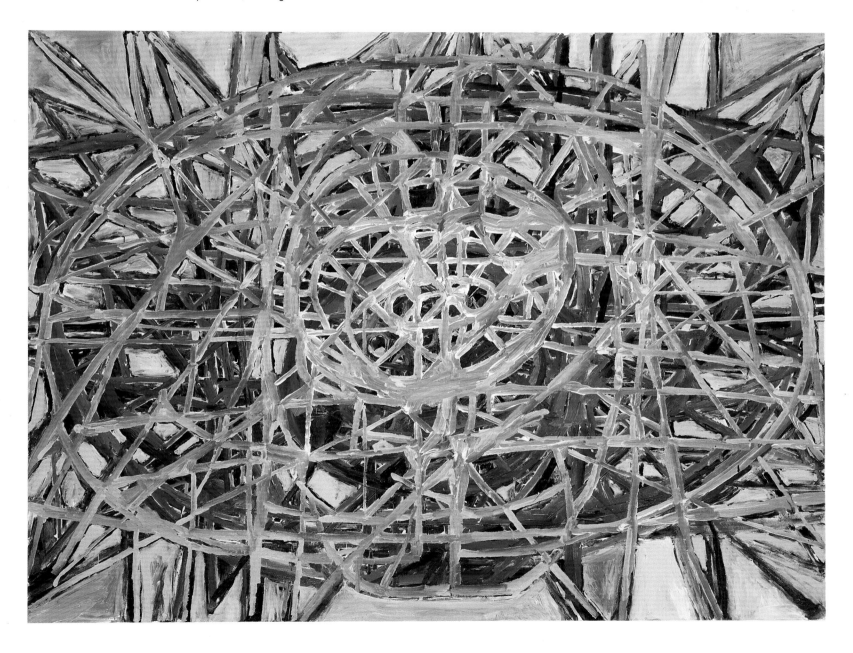

Figure 27. *Graphic Primitives, 6*, 1998. Oil and alkyd
resin on linen; 190.5 x 274.3 cm (75 x 108 in.).
Private collection.

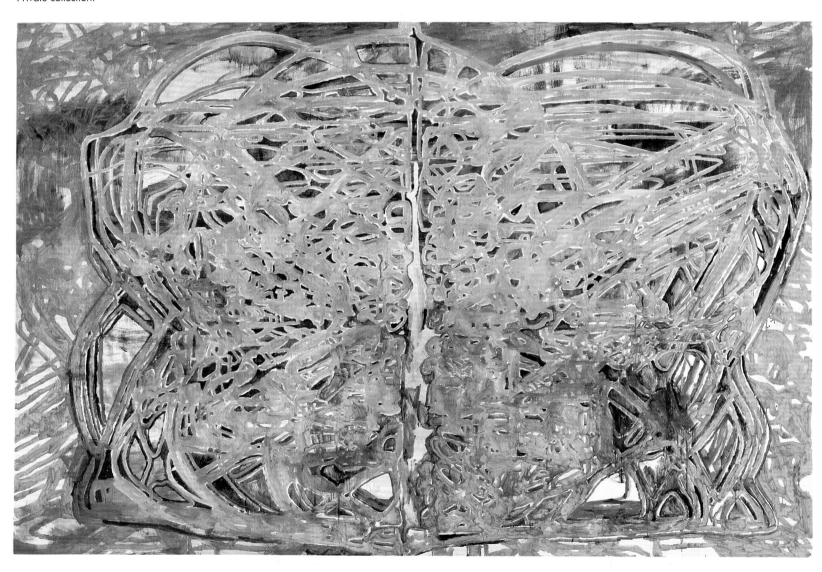

Figure 28. *Graphic Primitives, 6,* 1998. Woodcut (cat. no. 128).

of Chains drawings. To do this, Winters built up each system of grid, ellipse, and diagonal with discrete applications of aquatint that varied in the initial depth of the acid bite and in the coarseness or fineness of the rosins. When the single plate was wiped, it attracted the ink in varying degrees of saturation. When printed and pulled, the image displayed the mysterious overlayering of line in the paintings, but also the variously aquatinted passages presented the ink in a nuanced range of colors from navy to slate blue. These shifts of color were due to the particular nature of the synthetic ink. Winters had let the process take the image to where it wanted to go. This reciprocity of medium and image would continue to be felt in Winters's succeeding elaborations upon the *Computation of Chains* drawings.

In 1997, Winters began work on another set of etchings derived from *Computation of Chains.* They were intended to be the basis for an artist's book done in collaboration with noted literary critic and intellectual historian Jean Starobinski, professor emeritus at the University of Geneva. Winters had met Starobinski, well known for his studies on Jean-Jacques Rousseau, earlier in the decade, admired his work, and discussed collaborating on a book. The process started with Winters sending prints to Starobinski, who would respond with texts, to which Winters would react with new prints. Out of this exchange, *Set of Ten*, a series of aquatint etchings, was created. As he had done with the earlier group of five etchings, he would develop one plate for each image. Rolled and wiped with black ink, the plate would produce a print in a single run through the etching press.

Although the pages of the proposed book were to be vertical, Winters wanted to use horizontal drawings. He introduced upper and lower horizontal images to bracket the vertical sheet and provide him with the format he desired. These bands, however, were not extraneous to the image. He reserved them for written notations serving as another form of marginalia. They carry suggestions of cryptic references that include abstract scrawls, barely legible calligraphy, and Arabic numerals in reverse that identify the sequence of ten prints. Winters conceived these borders, in part, in the spirit of those that appear in the illustrated plates of alchemical treatises. He had incorporated them into the etching *Chaos* from 1994 (fig. 31). He also saw this "darker world outside the image as creating an aperture for the image that extended in invisible ways."[16] In earlier print portfolios, first with *Folio*, and notably in *Fourteen Etchings* and *Models for Synthetic Pictures*, Winters incorporated language into his art as a form of metaphorical elucidation of his imagery. Language as he introduced it into the *Set of Ten*, albeit enigmatic, was for the artist "a register of what I was thinking about." Although Winters was originally developing drawings and plates for the Starobinski collaboration, the etchings had become "too physical" and resolved in ways that encouraged the artist to release them independently, although still related to the essay. He needed additional plates for the book, however, so he began new etchings that would be bound with text.[17]

Figure 29. *Rhizome,* 1998. Linoleum cut (cat. no. 133).

Yet another set of prints would come out of the *Computation of Chains* drawings. This time it was in another medium and with another publisher, David Lasry at Two Palms Press in New York. With *Graphic Primitives* (see fig. 28), released in 1998, Winters returned to the woodcut, although the new portfolio derived its character from the linoleum cuts of *Glyphs*. The basis for this series was a subset of nine related drawings from *Computation.* Winters's and Lasry's interests in exploring new printing methods led them to have the blocks cut by a laser. They had a machine incise Winters's drawings into cherry woodblocks, just as the artist had done by hand with the linoleum blocks of *Glyphs.* In another departure, Winters redrew his images on the computer, in order to format them for the cutting process and to see how the computer might affect the original drawings. What he quickly noticed and liked was the uniformity of the computer drawing, its lack of inflection, which was so different from his own drawing. Winters made a disk of the drawings and sent it out for laser processing onto the woodblocks. With computer and laser, Winters found himself "using machinery as a drawing instrument." During the fabrication of the blocks line was literally burned into the wood — flame and smoke arose as the laser drew into the surface.

Returning to the *rincée* method of *Glyphs,* Winters had the cherry blocks rolled with white oil paint and printed on white Japanese handmade paper. The printed sheet was then washed with black Sumi ink. Repelled by the oil paint, the ink wash soaked into the paper to silhouette the white printed rectangle of the cherry block and make visible the drawings, which now appeared in black and suggested what Winters saw as "charred lines." While finishing *Graphic Primitives,* in a major exchange between media, he decided to make nine large-scale paintings (see fig. 27) based on the nine woodcuts. The woodcuts gave the original drawings from *Computation of Chains,* upon which they were based, the qualities of almost specter-like blueprints for inscrutable structures, be they architectural, organic, or inorganic. Haunting on their own, the prints also existed as metaphorical negatives for processing into color enlargements — the nine magisterial and incandescent paintings.

Two prints, published in 1998, and both evolving out of the rich source book of *Computation of Chains,* reassert Winters's enduring enterprise as an artist. *Rhizome* (fig. 29), a linoleum cut made with Leslie Miller, reprises in its title the more purely organic identity of Winters's early prints. A rhizome is a root-like stem, just below or along the soil, that sends out roots and shoots. Winters was drawn to this form after reading a text by the French philosphers Gilles Deleuze and Félix Guattari. Deleuze and Guattari had argued that rhizomatic structures were a prime example of life-giving forces, as well as being an accurate universal model.[18] In the print, the design of the block suggests a resplendent tangle of growth in which — with the suggestion of a rhizome in thickening linework at the center — the core, the tendrils, and the roots merge into one. Yet woven into this network is the subtle suggestion of

a geometric grid, which provides a metaphorical link to the principle of highly structured organizing forces.

As a comparative foil to *Rhizome,* which shows Winters's continuing mastery of black ink as a determining element in his prints, *Multiple Visualization Technique,* an aquatint made at ULAE, is the most ecstatic color print the artist has made. It also declares Winters's control of aquatint printing with an image of infinite complexity that was produced with only four plates, each inked, respectively, in yellow, blue, red, and black, and overprinted in single runs through an etching press. From some mysterious, concealed source beneath and behind a tight embroidery of many reds, oranges, and black — at once organic, visceral, and minute — emanates an intense yellow brushed here and there with flecks of light cobalt blue. Neither this covert mandala of radiant light nor the sinewy drawing are separable from each other; each vitalizes the other as Winters reveals essential unities.

The drawings of *Computation of Chains* had triggered the most intense series of exchanges. The drawings, prints, and paintings of this group truly demonstrate that Winters's art is "the same body of work in all media." This may explain why he has little interest in state editions. Printmaking has a tradition of the artist reworking and reusing elements — block, stone, plate — to create a series of "states" for variation and extension of an image. This altering of the image through the processes of print media seems imminently suited to Winters. However, elaboration of printed imagery in Winters's art occurs either in a portfolio, with its lateral references to other images, or in drawing or painting. Winters speaks of a "history of forms biting into the plates" in his printmaking. His generation and monitoring of an individual print, as process takes the image in its own direction, "registers a definite and emotional moment." It comes home to rest, and that is it. Winters is interested in variety, but in the sense of getting other information out of a drawing by working it in print and painting media. If, in these respects, the drawings, paintings, and prints are of a particular whole, a claim could nonetheless be made for the prints that they occupy a distinctive position on their own.

From a certain perspective, the prints are paradigmatic for the essential character of Winters's art. The sequential and transformational aspects of printmaking as a process bear important resemblances to alchemy, the "art of transmutation." Arising in Europe during the late medieval and early Renaissance periods, its most important formulations were made in the sixteenth and seventeenth centuries, with only the Enlightenment dismantling its influence on intellectual thought. Alchemy provided the basis for describing the world and discerning relationships between all created matter. It argued for the essential unity of the universe. In Renaissance interpretations of the Cabala, an esoteric rabbinical tradition whose theosophical texts first appeared during the late Middle Ages, commentators joined alchemy to philosophy, astronomy, and the arts as a basis for understanding the mysteries of scripture and the divine realm above (fig. 30).

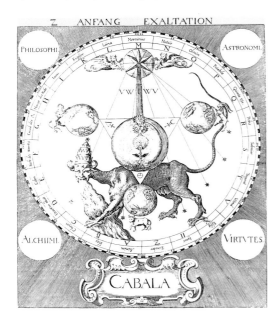

Figure 30. Plate from *Cabala, Spiegel der Kunst und Natur: in Alchymia,* by Steffan Michelspacher (Augsburg, Germany, 1616).

Figure 31. *Chaos,* 1994. Open bite etching, etching, spit bite aquatint, and lithograph (cat. no. 109).

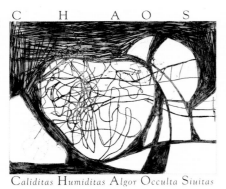

Central to alchemy was the "philosophers' stone." Understood by some to be an idea or great principle, it appears most often in the literature as a substance. Distilled by the alchemist from base materials through a process of transmutations, it is probably best known as the gold made from lead, or the alchemical substance that performs the miraculous change. But alchemists also aspired to distill the "Elixir of Life" from the philosophers' stone to prolong life and cure all diseases. The magical stone was the "great panacea" that would serve as a catalyst in the spiritual redemption of humanity and the universe. It was a mystical thing referred to by many names: gold, sun, red earth, water of sulphur, mercury, tail of the dragon, Urine, white lead, silver, salt, Father of Minerals, and Bark of the Sea. It was also known as Chaos.[19]

Chaos means "empty space" in ancient Greek; it was the disordered state of unformed matter prior to an ordered universe. In 1993, Winters produced his *Chaos* (fig. 31) in response to a request by Yale University Art Gallery to submit a print for its exhibition "Reinventing the Emblem: Contemporary Artists Recreate a Renaissance Idea." Winters derived the image and its format from an alchemical emblem book, *Escalier des Sages,* written by Barent Coenders van Helpen in 1689 (see fig. 32). Above and below Winters's inchoate, protean drawing are borders for title and caption, emulating Van Helpen's illustration and anticipating the annotated margin areas of the *Set of Ten*. A description at the bottom reads: "Chaos surrounded by night formed the envelope under which Cosmic Matter was slowly organized by the creative action of Aether." Matter exists by the intermingling of Aether (the heavens above) and Chaos; an ordered universe then comes into existence.

Winters's choice of *Chaos* for the Yale print? The artist, like Aether, creates order out of nothing: the work of art. In Chaos Theory, modern physics renews the arguments of the ancients. Chaotic systems in nature are described by fractal geometry in a language of algorithms. According to this description of the world, small local changes within the universe can generate global differences: an observation that argues for the underlying connections in all that surrounds us. The imagining intelligence of the artist, like eternally creating nature, has the power to originate things. Winters poeticizes the congruence of nature and art in his personalizing of the alchemical emblem of Chaos.

The trajectory of Winters's iconography has ranged from his early images representative of the initial stages of organic growth to his more recent synthesis of the organic and the technical, where "the boundaries between the natural and the artificial aren't so distinct."[20] Winters, like Paul Cézanne, has wished to create a "new description of nature." He has visualized it by abstract and referential means, and like Wassily Kandinsky's ideal of a spiritualized nature revealed to humanity through art, there is a regenerative dimension to Winters's art. Speculative late twentieth-century physics, like the propositions of alchemy, wishes to under-

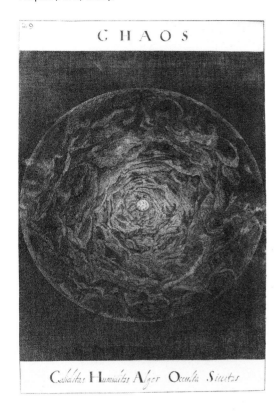

Figure 32. Plate from *Escalier des Sages ou la philosophie des anciens*, by Barent Coenders van Helpen (Paris, 1689).

stand all and fervently dreams of a universal principle that ties everything together in "Grand Unifying Theories," which reveal the wholeness of complexity and multiplicity. So dreams the alchemist, and so Terry Winters.

The alchemist's intuitions prompted attempts to transform ordinary materials into extraordinary agents with redemptive powers. Early on, when first entertaining prints, Winters was attracted to "the idea of taking an infinitesimal amount of material and making a dense physical object." In his printmaking, he has taken stone, plate, block, and additional materials from nature in the form of acids, tars, rosins, and other substances to get started. Through a progressive series of steps and processes, which have included melting wax and burning wood, he transfigures all of these base materials into an image. Winters's nothing into something has become a compelling and deeply moving body of work: his prints.

Notes

1. "Work Notes," typescript, 1962, Universal Limited Art Editions Archives, West Islip, New York.

2. In conversation with the author, May 1-2, 1998, New York. Unless otherwise noted, all subsequent quoted remarks are the artist's and come from this two-day interview.

3. For an extended discussion of Winters's fascination with the history of pigments and the technology of their use, see Lisa Phillips's essay, "The Self Similar" in *Terry Winters* (New York: Whitney Museum of American Art, exh. cat., 1991), 14-15.

4. The first significant printed natural histories appear in the sixteenth century. A standard for botanical illustration was set by Otto Brunfels's *Herbarum vivae eicones* (Strasbourg, 1530-36) with woodcuts by Hans Weiditz. One of the finest floral catalogues was Basilius Besler's set of engravings for *Hortus Eystettensis*, which was published in Germany in several editions in the early seventeenth century. Besler and his patron, the Prince Bishop of Eichstätt, whose gardens the book documents, aspired to a comprehensiveness that came to distinguish such projects. They wished to present and annotate all the shrubs and flowering plants known to exist at the time.

5. The exhibition "Terry Winters" was curated by Lisa Phillips for the Whitney Museum of American Art, New York. It opened at the Museum of Contemporary Art, Los Angeles, in September 1991, and appeared at the Whitney from February to April 1992.

6. Sue Scott, "Universal Limited Art Editions: The Artists' Chronology, 1982-1996," in *Proof Positive: Forty Years of Contemporary American Printmaking at ULAE, 1957-1997* (Washington, D.C.: The Corcoran Gallery of Art, exh. cat., 1997), 107.

7. My thanks to Jack Lilien, chair of the biology department, and Janne Balsamo, research professor, at Wayne State University, Detroit, for identifying Winters's biological forms and helping to clarify the level of abstraction in Winters's art.

8. "Terry Winters: Fourteen Drawings/Fourteen Etchings" at Jahn and Fusban Gallery, Munich, June 1990.

9. For an extended discussion of the relationships between Poe's *Eureka*, late nineteenth-century literature, and *Fourteen Etchings*, see David Shapiro's essay, "Terry Winters: Symbolism and Its Discontents" in *Terry Winters: Fourteen Drawings/Fourteen Etchings* (Munich: Verlag Fred Jahn, exh. cat., 1990).

10. For a full account of the *kunstkammer* in the Netherlands, see Arthur K. Wheelock, Jr., *A Collector's Cabinet* (Washington, D.C.: National Gallery of Art, exh. cat., 1998).

11. Blaise Pascal, *Pensées* (Baltimore: Penguin Books, 1966), 95.

12. For an extended description and history of Picasso's linocuts and his *épreuves rincées*, see Brigitte Baer, *Picasso the Printmaker: Graphics from the Marina Picasso Collection* (Dallas Museum of Art, exh. cat., 1983) 151-153.

13. Scott Gutterman, "Facts of Life: Terry Winters Describes the Irreducible Nature of Existence in Paint," *The Journal of Art* 4, 7 (September 1991): 38-40.

14. Terry Winters, *Ocular Proofs* (New York: The Grenfell Press, 1995).

15. See "Conversation with Adam Fuss," in *Terry Winters: Computation of Chains* (New York: Matthew Marks Gallery, exh. cat., 1997), 16.

16. In a series of what he calls his "field paintings," which he had made prior to work that appeared in the Sonnabend Gallery exhibition of 1982, Winters used the device of borders to include information about the history of the pigments that made up the image. He did this in efforts to block any self-referential dimension of what might be construed to be a purely abstract painting.

17. These etchings led to an extended series of smaller prints, from which Winters selected over two dozen for inclusion in the book that was still in preparation at the time of this writing.

18. See Gilles Deleuze and Félix Guattari, "Introduction" in *A Thousand Plateaus: Capitalism and Schizophrenia* (Minneapolis: University of Minnesota Press, 1987).

19. From William Gratacolle, "Names of the Philosophers" in *Five Treatises of the Philosophers' Stone* (London, 1652).

20. "Conversation with Adam Fuss" (note 15), 9.

CATALOGUE RAISONNÉ

Key to the Catalogue Raisonné

All information pertaining to medium, type of paper, names of colors, and specifics of printing sequences reflect information provided by printers, publishers, and/or the artist. Prints are arranged in chronological order. For the portfolios, illustrations of boxes, folders, and text pages appear at the beginning of each set of prints and are identified in the text following the description of the printing sequence for each entry.

Dimensions In many cases, traditional measurements (separating image size from sheet size for lithographs, woodcuts, and screenprints; and plates from sheets for intaglios) do not apply to the works in this catalogue. In cases like *Ova*, *Locus*, and many others, the large blank portions of the sheet are considered part of the image. Because many sheets are hand torn to size or handmade with highly irregular edges, the sheet sizes are approximations and can easily vary by one-quarter inch or more among prints in an edition.

Signatures, Edition Numbers, and Dates Unless otherwise indicated, all signatures, edition numbers, and dates are inscribed in pencil. The signing, dating, and numbering of prints are listed in the exact order in which the information appears on the prints.

Inscriptions and Drystamps Unless otherwise indicated, all inscriptions are in pencil. The location of all inscriptions and some of the drystamps (embossments) is given followed by the exact wording of the information.

Publishers Universal Limited Art Editions, West Islip, N.Y., is referred to as ULAE. All other publishers' names are given in full.

Proofs and Editions In the general entry for each portfolio, the numbering for the edition and proofs reflects complete sets of the particular work. *Folio* (cat. nos. 9-19), for example, has an edition of thirty-nine complete portfolios (designated 39), plus six complete portfolios for the artist (6 AP), one complete portfolio for the printer/publisher (1 PP), and two complete portfolios hors commerce (2 HC). Two complete sets of trial proofs exist for each of the eleven prints in the portfolio (2 TP), as well as two complete sets of color separations for each of the prints. If any individual print from a portfolio has more proofs than those described in the general entry, these impressions are listed for the specific work in question.

AP Artist's proof(s). Prints made in addition to the edition and set aside for the artist. They equal the edition prints in all respects.

BAT and/or RTP Bon à tirer or Right to Print. A print approved by the artist to serve as the standard for the edition.

BN Bibliothéque nationale de France. A print equal to the edition prints set aside for the library's collection.

HC Hors commerce. Proofs not intended for sale. They may or may not differ from the edition prints.

PP Printer's/publisher's proof(s). Prints made in addition to the edition and set aside for the printer(s) and/or publisher(s). They equal the edition prints in all respects.

TP Trial proof(s). Test proofs that differ in appearance from the edition prints.

VP Variable proof(s). Uncategorized proofs that vary significantly from the other types of proofs and the edition prints.

WP Working proof(s). Test proofs incorporating additions by hand or other means that reflect experimentation with the development of the image.

Archival proofs. A print in the ULAE archives.

Color separations. For prints of many colors made from multiple blocks, plates, or stones, color separations are proofs printed in only one color to test the quality of that color when printed from a particular block, plate, or stone.

Progressive proofs. For prints with many colors or with effects made from multiple blocks, plates, or stones, progressive proofs document the cumulative sequence of colors or effects for a particular image.

Signing proofs. A ULAE term for proofs testing placement of the signature.

State proofs. Impressions made at different stages in the development of a print to check on the progress of the image and/or the quality and condition of the block, plate, or stone.

Colors and Printing Sequence Information about these details is as accurate and complete as possible at the time of publication. All blocks, plates, stones, and screens have been canceled or destroyed unless otherwise noted.

1. Ova 1982

Lithograph printed in two colors on English
mouldmade paper
Image and sheet: 74.9 x 54.6 cm (29¹/₂ x 21¹/₂ in.)
Signed (*T Winters*), numbered, and dated (*1982*),
lower right corner
Publisher's drystamp, lower right corner

Edition: 7 plus 2 AP, 3 PP
Proofs: 4 TP on various papers
Printers: Thomas Cox, Bill Goldston
Publisher: ULAE

Colors: Proofing black, process black

Printing sequence: Two printings from two stones
printed on a hand transfer lithographic press.
1) proofing black 2) process black

2. Factors of Increase 1983

Lithograph printed in one color on Moulin du Verger
handmade paper
Image and sheet (irregular): 78.7 x 55.9 cm
(31 x 22 in.)
Signed (*TW*) and dated (*1983*), lower right corner
Numbered, lower left corner
Publisher's drystamp, lower left corner
Artist's drystamp, lower right corner: *tw*

Edition: 30 plus 7 AP, 3 PP
Proofs: 1 signed TP; 4 unsigned, stamped (*ULAE; tw*)
archival proofs
Printer: Thomas Cox
Publisher: ULAE

Color: Proofing black

Printing sequence: Four printings from two stones
and two plates printed on a hand transfer lithographic
press; 1-2 from stones; 3-4 from plates.

3. Morula I 1983-84

Lithograph printed in two colors on Japanese handmade Toyoshi paper (torn to size)
Image and sheet (irregular): 106.1 x 80.3 cm (41³/₄ x 31⁵/₈ in.)
Signed (*TW*) and dated (*1983-1984*), upper right corner
Numbered, upper left corner
Publisher's drystamp, upper left corner

Edition: 38 plus 5 AP, 3 PP
Proofs: 2 signed WP (placement of signatures varies), 3 signed TP
Printers: Keith Brintzenhofe, Thomas Cox
Publisher: ULAE

Colors: Proofing black, brown

Printing sequence: Four printings from one stone and three plates; 1-3 printed on a hand transfer lithographic press by Cox; 4 printed on a hand-fed offset lithographic press by Brintzenhofe.
1) proofing black 2) brown 3) proofing black, reduced color [stone] 4) proofing black

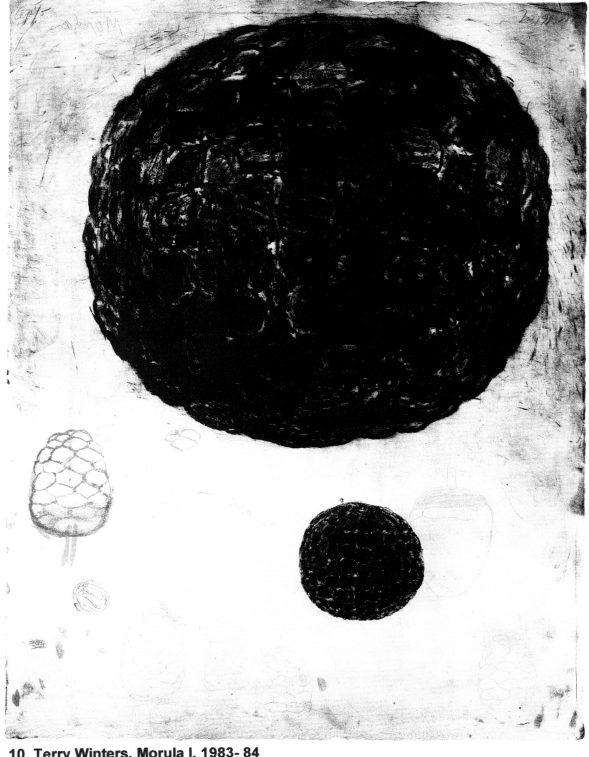

10. Terry Winters, <u>Morula I</u>, 1983- 84

4. Morula II 1983-84

Lithograph printed in three colors on Japanese handmade Toyoshi paper (torn to size)
Image and sheet (irregular): 107.3 x 82.5 cm (42 ¼ x 32 ½ in.)
Signed (*TW*) and dated (*1983-84*), lower right corner
Numbered, lower left corner
Publisher's drystamp, lower left corner

Edition: 37 plus 6 AP, 3 PP
Proofs: 3 signed WP (placement of signature varies), 3 signed TP
Printers: Keith Brintzenhofe, Thomas Cox
Publisher: ULAE

Colors: Proofing black, graphite, mixed brown

Printing sequence: Eight printings from three stones and five plates; 1-6 printed on a hand transfer lithographic press by Cox; 7-8 printed on a hand-fed offset lithographic press by Brintzenhofe.
1) proofing black [plate] 2) graphite [plate]
3) mixed brown [plate] 4-5) graphite [stones]
6) proofing black [stone] 7) mixed brown [plate]
8) proofing black [plate]

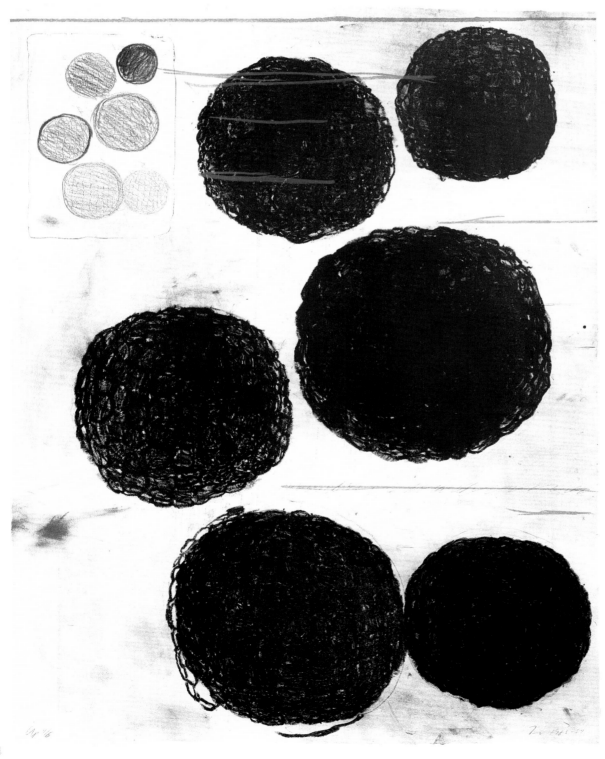

5. Morula III 1983-84
Lithograph printed in three colors with additions by hand in graphite pencil on Japanese handmade Toyoshi paper (torn to size)
Image and sheet (irregular): 106.7 x 82.5 cm (42 x 32 ½ in.)
Signed (*TW*) and dated (*1983-84*), upper right corner
Numbered, upper left corner
Publisher's drystamp, upper left corner

Edition: 36 plus 5 AP, 3 PP
Proofs: 6 signed WP (placement of signature varies), 4 signed TP
Printers: Keith Brintzenhofe, Thomas Cox
Publisher: ULAE

Colors: Black, white, graphite

Printing sequence: Eight printings from eight plates; 1-6 printed on a hand transfer lithographic press by Cox; 7-8 printed on a hand-fed offset lithographic press by Brintzenhofe.
1) black 2) white, graphite 3-5) white 6) black 7-8) graphite

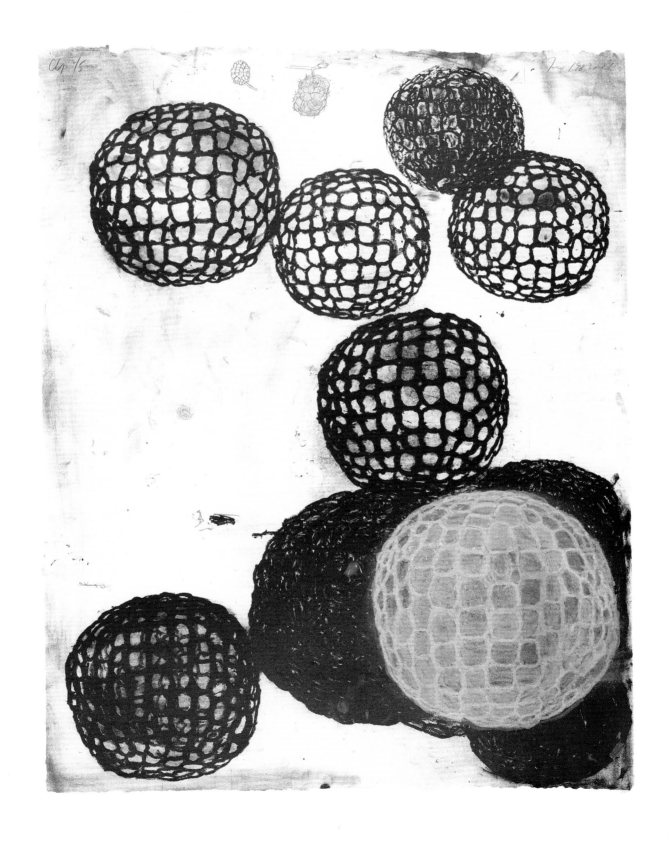

6. Double Standard 1984
Lithograph printed in twenty-two colors on Arches
paper (torn to size)
Image and sheet (irregular): 198.1 x 106.7 cm
(78 x 42 in.)
Signed (*TW*) and dated (*1984*) in heavy black
marking pencil, lower right corner
Numbered in heavy black marking pencil,
upper right corner
Publisher's drystamp, lower left corner

Edition: 40 plus 8 AP, 2 PP, 11 HC
Proofs: 4 WP, 6 TP, 4 initialed archival proofs
Printers: Keith Brintzenhofe, John Lund, Douglas Volle
Publisher: ULAE

Colors: Seventeen variations of proofing black,
two variations of graphite, two variations of noir
à monter, brown

Printing sequence: Eighteen printings from eighteen
plates; seventeen printings from seventeen plates
printed on a hand transfer lithographic press by
Brintzenhofe and one printing from one plate
printed on a hand-fed offset lithographic press
by Lund and Volle.
1-3) proofing blacks 4-5) proofing blacks, graphite
6-9) proofing blacks 10) graphite 11-12) noirs à monter
13-14) proofing blacks 15) graphite 16-17) proofing
blacks 18) brown

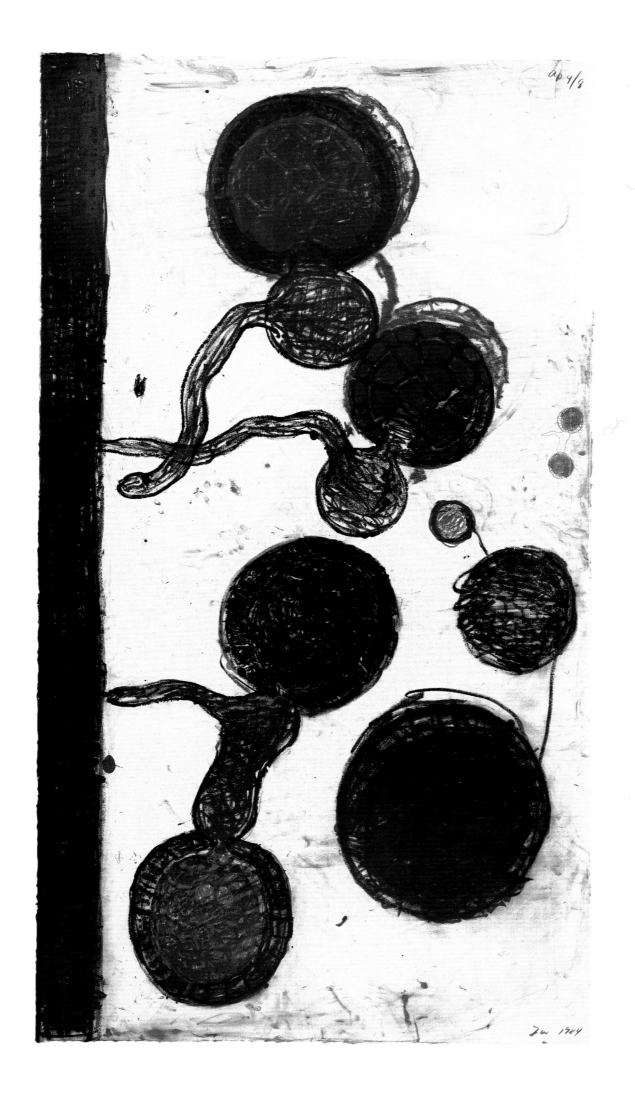

7. Primer 1985

Lithograph printed in eight colors on J. Whatman
1961 handmade English paper
Image and sheet: 78.7 x 58.4 cm (31 x 23 in.)
Signed (*TW*) and numbered, upper right corner
Dated (*11/85*) in heavy marking pencil, lower
right corner
Publisher's drystamp, lower left corner

Edition: 66 plus 10 AP, 2 PP
Proofs: 1 signed BAT, 8 signed WP on various papers
(placement of signatures varies), 5 signed TP
Printer: Keith Brintzenhofe
Publisher: ULAE

Colors: Writing black, classic black, proofing black,
silver, yellow, vermillion red, monastral blue, royal blue

Printing sequence: Thirteen printings from twelve plates
printed on a hand-fed offset lithographic press.
1-7) various blacks 8) silver 9) yellow
10-11) red [from the same plate] 12-13) blues

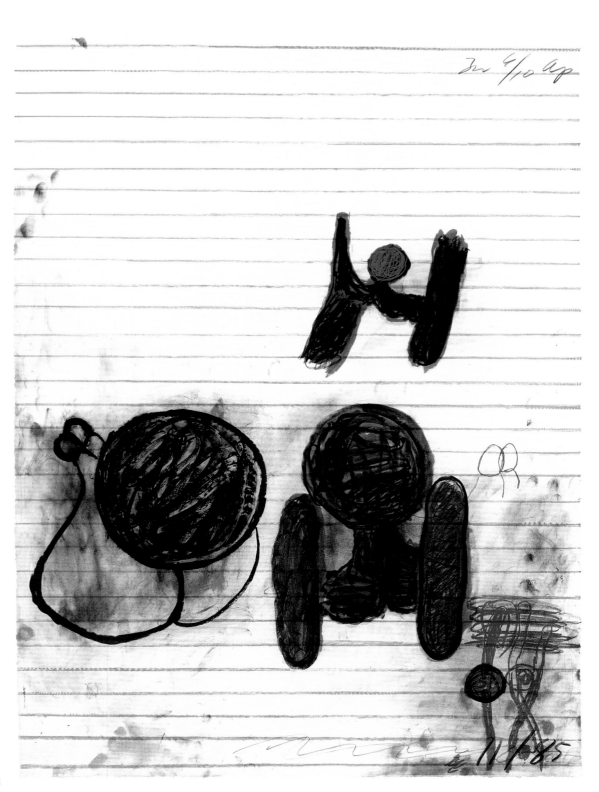

8. Untitled (Brooklyn Academy) 1986
Lithograph printed in nine colors on Arches Cover
Stock paper
Image and sheet: 76.2 x 57.1 cm (30 x 22 ½ in.)
Signed (*TW*) and dated (*86*), lower left corner
Numbered, upper left corner

Edition: 75 plus 16 AP, 1 PP, 10 HC
Proofs: 1 signed WP, 7 signed TP, 2 unsigned VP
stamped *ULAE* and/or *tw*
Printer: Keith Brintzenhofe
Publisher: Brooklyn Academy of Music

Colors: Brown, two graphites, noir à monter, two
writing blacks, two proofing blacks, process black

Printing sequence: Nine printings from nine plates
printed on a hand-fed offset lithographic press at
ULAE.
1) brown 2) graphite 3) noir à monter
4) writing black 5-6) proofing blacks
7) writing black 8) graphite 9) process black

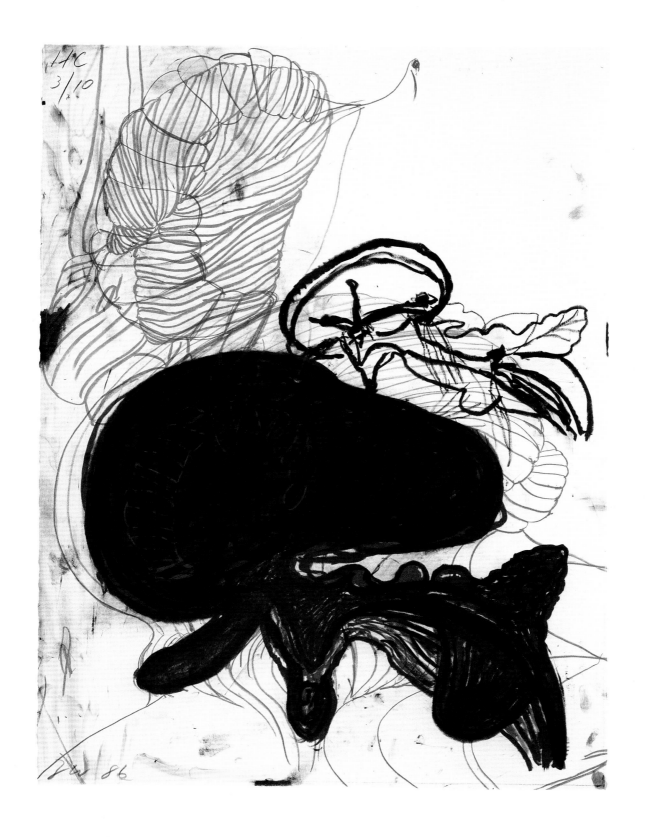

9–19. Folio 1985-86

Portfolio of eleven lithographs printed
in color on J. Whatman paper, including title page
and colophon, printed in color on John Koller
handmade paper
Images and sheets (irregular): 81.3 x 58.4 cm
(32 x 23 in.)
Signed in varying locations on each sheet
Numbered on title page
Title of each individual print stamped in blue ink,
lower left verso of each sheet
Publisher's drystamp, lower left corner of each sheet
Watermark on title page and colophon: *Terry Winters*

Edition: 39 portfolios plus 6 AP, 1 PP,
2 HC
Proofs: 2 TP, 2 sets of color separations plus various
additional proofs listed accordingly for the individual
prints
Printer: Keith Brintzenhofe
Publisher: ULAE

Printing sequence: All printings made on a hand-fed
offset lithographic press.

Issued in a linen-covered, three-fold paperboard
folder contained in a linen-lined Gabon ebony box
(see illustration, this page) designed by Terry Winters,
constructed by Frank D'Agostino, and lined by Sky
Meadows Bindery.

9. Folio, Title Page

Lithograph printed in fourteen colors
Signed (*TW*) and dated (*1985-1986*), lower center
Numbered, lower right following title
Inscribed on plate and printed in black ink, lower
center: *Folio / Terry Winters*
Proofs: 2 TP

Colors: Proofing black, writing black, perm yellow, green, purple, monastral blue, rose red, orange, white, velvet black, lemon yellow, vermillion red, crayon black, royal blue

Printing sequence: Eleven printings from twelve plates. 1) proofing black [two plates] 2-3) writing black 4) perm yellow, green, purple, monastral blue, rose red, orange, white, velvet black 5) white 6) perm yellow, green, purple, monastral blue, rose red, orange, white, velvet black 7) proofing black 8) lemon yellow, green, royal blue, vermillion red, purple, orange, white, velvet black, crayon black 9-10) crayon black 11) writing black

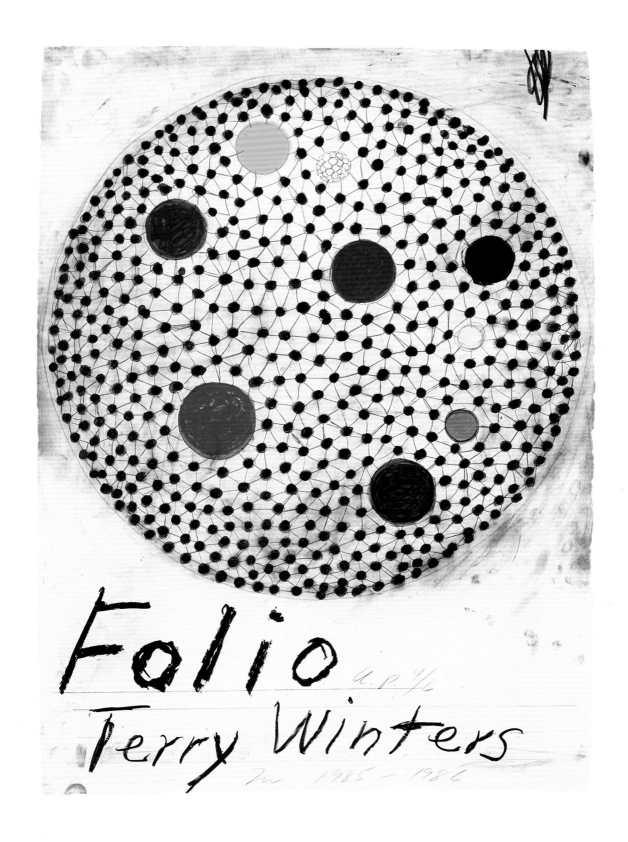

10. Folio One

Lithograph printed in six colors
Signed (*TW*), lower right corner
Proofs: 1 WP, 1 TP

Colors: Proofing black, graphite, writing black,
yellow, vermillion red, royal blue

Printing sequence: Nine printings from nine plates.
1-2) proofing black 3) graphite 4-5) proofing black
6) writing black 7-8) yellow, vermillion red, royal blue
9) writing black, yellow, vermillion red, royal blue

11. Folio Two

Lithograph printed in three colors
Signed (*TW*), lower left corner
Proofs: 2 BAT, 1 WP, 1 TP

Colors: Brown, white, proofing black

Printing sequence: Four printings from four plates.
1) brown 2-3) white 4) proofing black

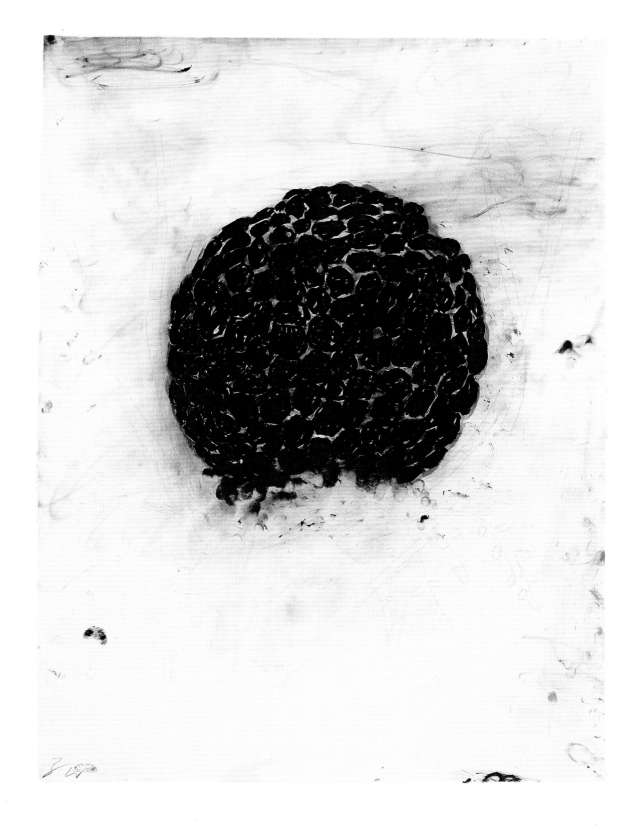

12. Folio Three

Lithograph printed in four colors
Signed (*TW*), upper right corner
Proofs: 1 BAT

Colors: Writing black, noir à monter, graphite, silver

Printing sequence: Four printings from four plates.
1) writing black 2) noir à monter 3) graphite 4) silver

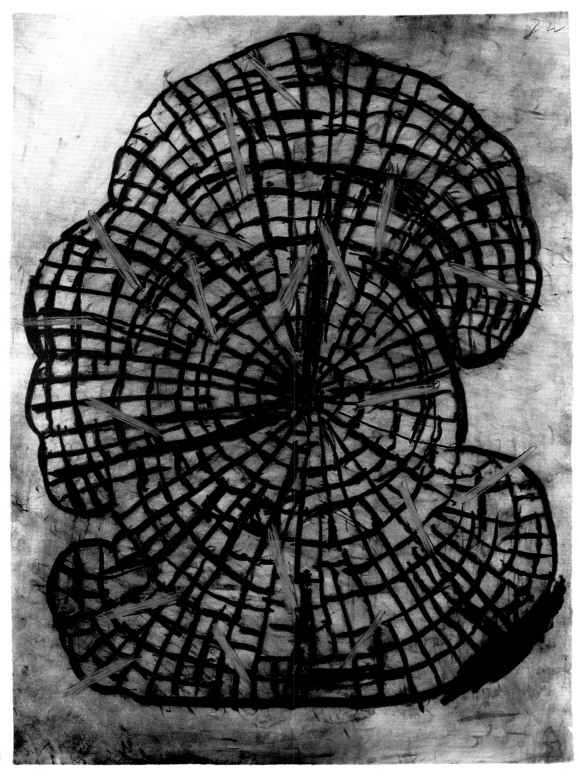

13. Folio Four

Lithograph printed in nine colors
Signed (*TW*), lower right corner

Colors: Proofing black, monastral blue, red, rose red, lemon yellow, noir à monter, writing black, vermillion red, royal blue

Printing sequence: Sixteen printings from sixteen plates.
1-2) proofing black 3) monastral blue 4) red
5) proofing black 6) rose red 7) lemon yellow
8-9) noir à monter 10-11) writing black 12) writing black, vermillion red, lemon yellow, royal blue
13-14) red 15) noir à monter 16) writing black

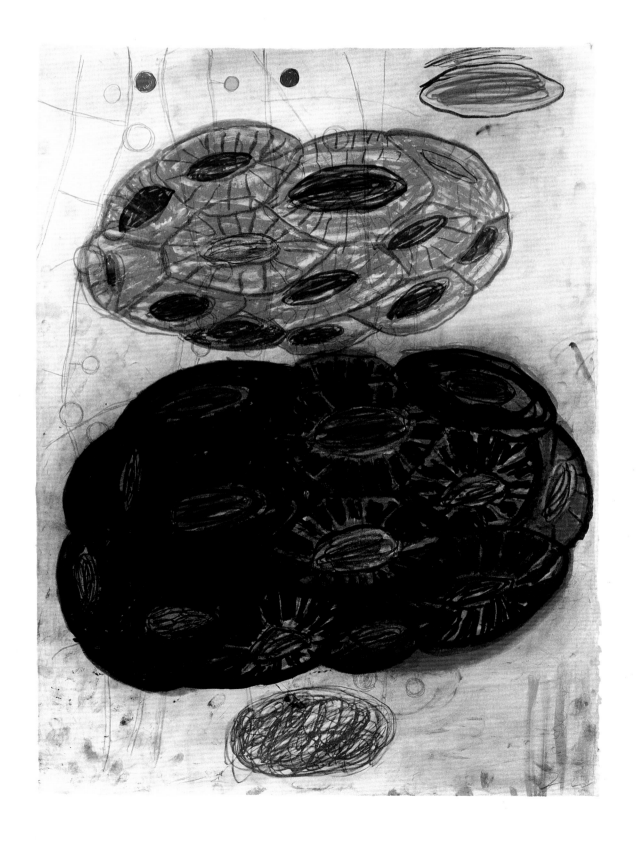

14. Folio Five

Lithograph printed in four colors
Signed (*TW*), upper left corner
Proofs: 2 BAT, 10 color separations

Colors: Proofing black, writing black, graphite, white

Printing sequence: Seventeen printings from sixteen plates.
1-2) proofing black 3-4) writing black 5-7) white
8-9) writing black 10) writing black [same plate as 2]
11) writing black 12) graphite 13-14) white
15-17) writing black

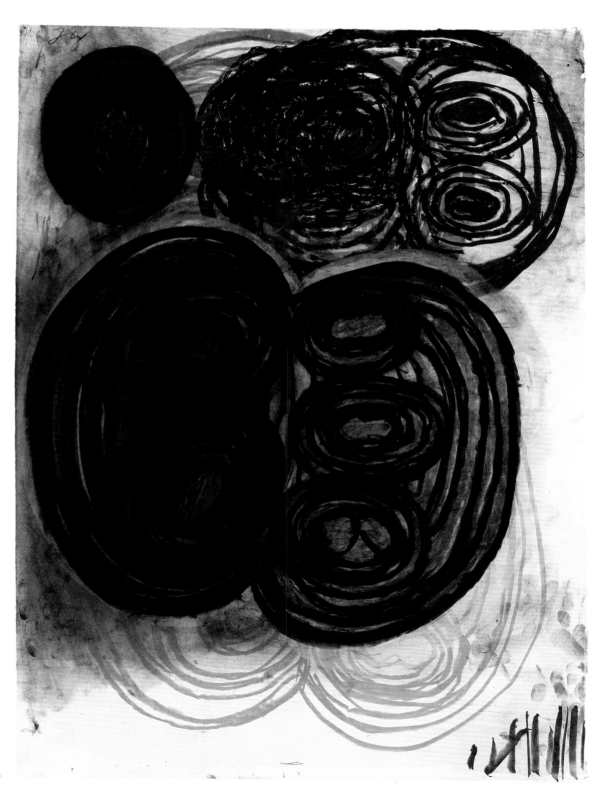

15. Folio Six

Lithograph printed in six colors
Signed (*TW*), lower right corner
Proofs: 3 TP

Colors: Red, noir mat, white, writing black, graphite,
dull black

Printing sequence: Twelve printings from twelve plates.
1-2) red 3) noir mat 4) white 5) writing black
6) graphite 7) red 8-10) writing black 11) dull black
12) graphite

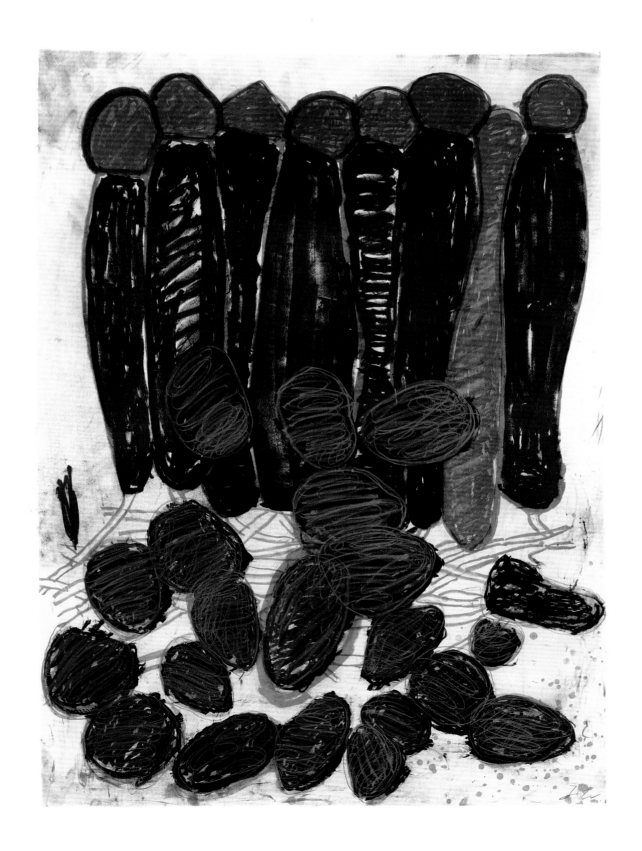

16. Folio Seven

Lithograph printed in thirteen colors
Signed (*TW*), lower right corner
Proofs: 1 BAT, 3 WP, 2 TP

Colors: Red, writing black, light brown, brown, yellow,
rose red, vermillion red, purple, royal blue, monastral red,
green, monastral blue, orange

Printing sequence: Ten printings from ten plates.
1) red 2-3) writing black 4) light brown 5) writing
black 6) brown 7) yellow, rose red, vermillion red, purple
8) royal blue, monastral red, yellow, green, purple
9) royal blue, monastral blue, orange, yellow, green,
purple 10) writing black

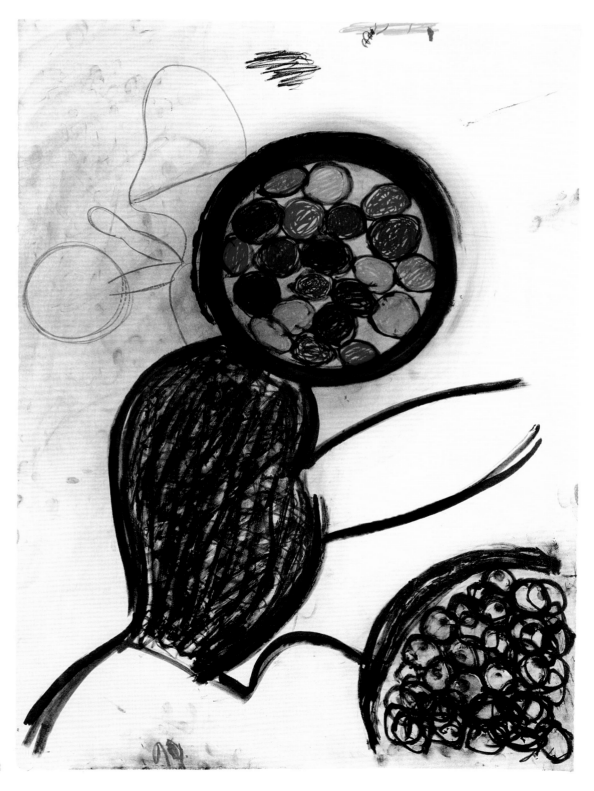

17. Folio Eight

Lithograph printed in six colors
Signed (*TW*), lower right corner

Colors: Proofing black, silver, white, writing black, purple, rose red

Printing sequence: Eight printings from eight plates. 1) proofing black 2-3) silver 4-5) white 6) writing black, purple 7) writing black 8) rose red

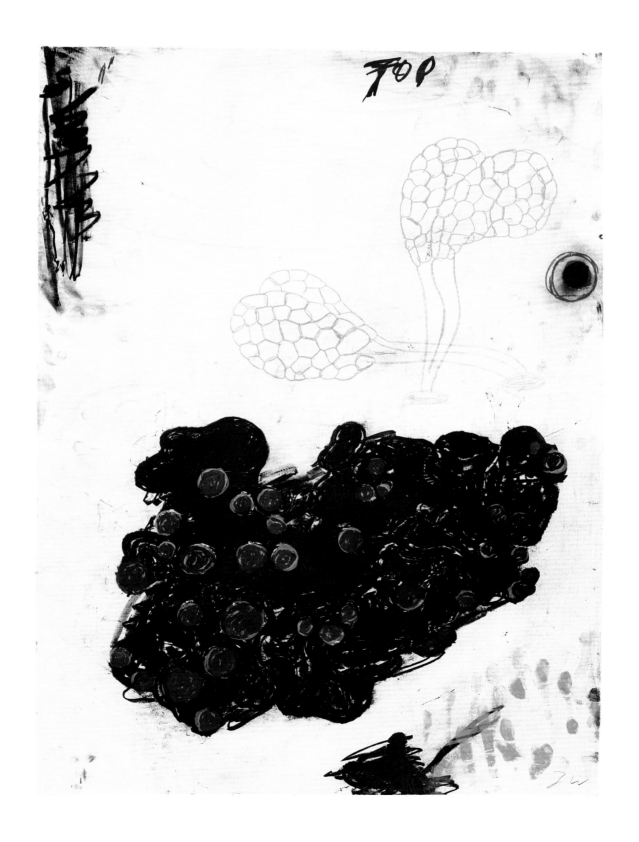

18. Folio Nine

Lithograph printed in fifteen colors
Signed (*TW*), lower right
Proofs: 2 TP

Colors: Goldenrod, eye-ease blue, stationary blue, green, writing black, monastral blue, velvet black, royal blue, white, yellow, noir à monter, vermillion red, graphite, proofing black, orange

Printing sequence: Forty-one printings from forty-one plates.

1) goldenrod, eye-ease blue [from two plates]
2) stationary blue 3) green 4-5) writing black
6) monastral blue 7-8) writing black 9) monastral blue
10) velvet black 11) royal blue 12) white 13) yellow
14) noir à monter [same plate as 5] 15) white
16) vermillion red 17) yellow 18-19) noir à monter
20) writing black 21) vermillion red 22) white
23) royal blue 24) white 25) graphite 26) velvet black
27) writing black 28) proofing black 29) monastral blue
30) green 31-33) monastral blue 34) vermillion red
35) monastral blue 36) proofing black 37) vermillion red
38) yellow 39) vermillion red 40) orange
41) proofing black

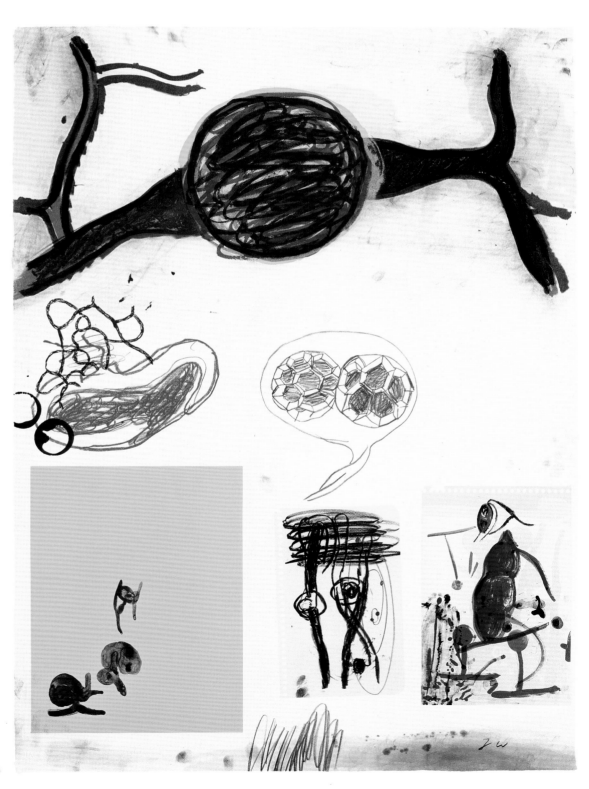

19. Folio, Colophon

Lithograph printed in twenty-three colors
Signed (*TW*), lower right corner

Colors: Silver, light brown, brown, red, noir à monter, proofing black, writing black, monastral blue, purple, vermillion red, royal blue, rose red, orange, white, velvet black, dull black, green, classic black, crayon black, noir mat, graphite, perm yellow, lemon yellow

Printing sequence: Eight printings from four plates (some plates used repeatedly).
1) silver, light brown, brown, red, noir à monter, proofing black, writing black 2) monastral blue, purple, vermillion red, lemon yellow 3) royal blue, rose red, orange, yellow 4) white, velvet black, dull black 5) green, silver, classic black, crayon black, noir mat 6) graphite, light brown, brown, monastral red 7) monastral blue, royal blue, purple, vermillion red, orange, perm yellow, lemon yellow 8) proofing black

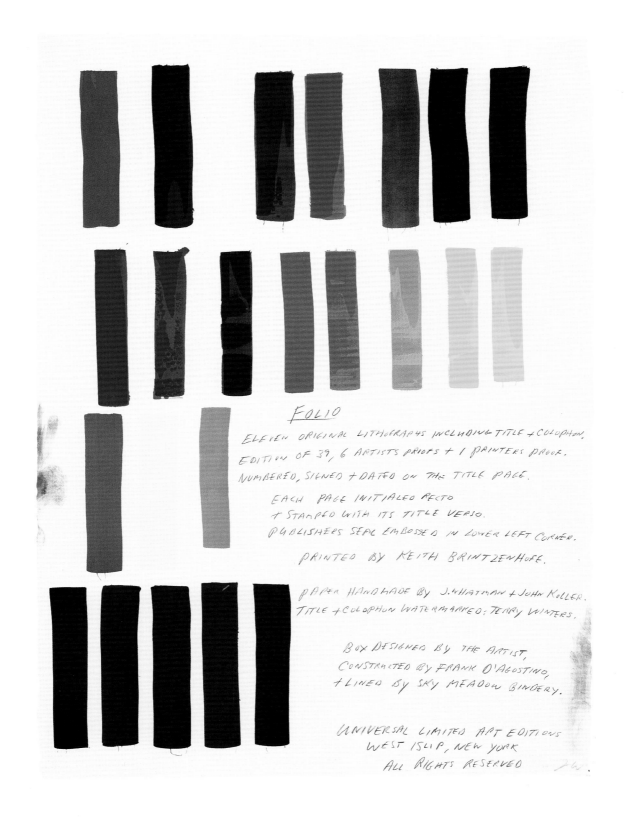

FOLIO

ELEVEN ORIGINAL LITHOGRAPHS INCLUDING TITLE + COLOPHON.
EDITION OF 39, 6 ARTISTS PROOFS + 1 PRINTERS PROOF.
NUMBERED, SIGNED + DATED ON THE TITLE PAGE.

EACH PAGE INITIALED RECTO
+ STAMPED WITH ITS TITLE VERSO.
PUBLISHERS SEAL EMBOSSED IN LOWER LEFT CORNER.

PRINTED BY KEITH BRINTZENHOFE.

PAPER HANDMADE BY J. WHATMAN + JOHN KOLLER.
TITLE + COLOPHON WATERMARKED: TERRY WINTERS.

BOX DESIGNED BY THE ARTIST,
CONSTRUCTED BY FRANK D'AGOSTINO,
+ LINED BY SKY MEADOW BINDERY.

UNIVERSAL LIMITED ART EDITIONS
WEST ISLIP, NEW YORK
ALL RIGHTS RESERVED

20. Untitled 1987

Lithograph printed in eleven colors on blue-green handmade J. Greene & Son paper
Image and sheet (irregular): 81.9 x 59 cm (32 ¼ x 23 ¼ in.)
Signed (*T Winters*), upper left corner
Numbered and dated (*1987*), below signature
Publisher's drystamp, lower left corner

Edition: 71 plus 8 AP, 2 PP
Proofs: 1 signed WP, 3 signed TP, 1 signed BAT, 2 sets of color separations
Printers: Keith Brintzenhofe, Douglas Volle
Publisher: ULAE

Colors: Purple, blue, green, red, yellow, white, various blacks

Printing sequence: Fifteen printings from fifteen plates; 1-6, 10, 13, and 14 printed on a hand transfer lithographic press; 7-9, 11, 12, and 15 printed on a hand-fed offset lithographic press.
1) purple 2) blue 3) green 4) red 5) yellow
6) white 7) purple 8) blue, yellow 9) red, green
10-15) various blacks

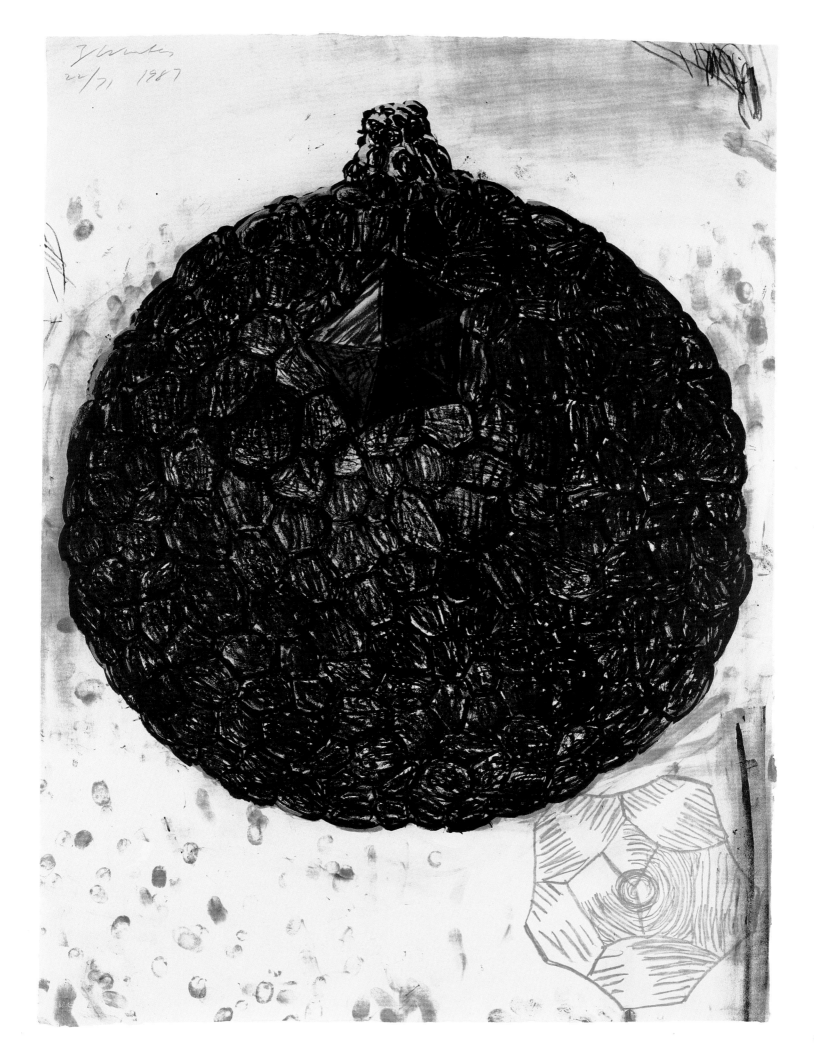

21–29. Album 1988

Portfolio of nine intaglio prints, including title page and colophon, printed in color on Hahnemühle paper
Plates: 51.4 x 40 cm (20 ¼ x 15 ¾ in.)
Sheets (irregular): 67.3 x 53.3 cm (26 ½ x 21 in.)
Signed (*TW*) lower left of each print, including the title page and colophon
Numbered, below signature
Titled by the artist following the stamp on the verso of each sheet
Printer's drystamp, lower right corner of each sheet: *ALDO/CROMMELYNCK/PARIS*
Stamped in light gray ink, lower center, verso of each sheet: *EIK*

Edition: 50 portfolios plus 10 AP, 5 PP, 2 HC, 1 BN
Proofs: 1 BAT plus various additional proofs listed accordingly for the individual prints
Printer: Atelier Aldo Crommelynck, Paris
Publisher: Editions Ilene Kurtz, New York

Printing sequence: Unless otherwise indicated, each print made in two printings from two plates on an etching press.

Issued in a gray linen casing (see illustration, this page) made by Jean Duval
Plates preserved for future consideration by the artist.

21. Album (Title Page)

Soft ground etching, spit bite aquatint, and
photogravure printed in two colors
Titled (*Album*) in plate, upper center
Signed and inscribed in plate, lower center:
Terry Winters / Paris 1988
Proofs: 2 TP

Colors: Two blacks

Printing sequence: 1) black [soft ground etching and
spit bite aquatint] 2) black [photogravure]

22. Album (1)

Soft ground etching, sugar lift aquatint, and spit bite
aquatint printed in two colors
Proofs: 1 WP, 3 TP

Colors: Black, gray

Printing sequence: 1) gray [spit bite aquatint
and sugar lift aquatint] 2) black [soft ground etching
and spit bite aquatint]

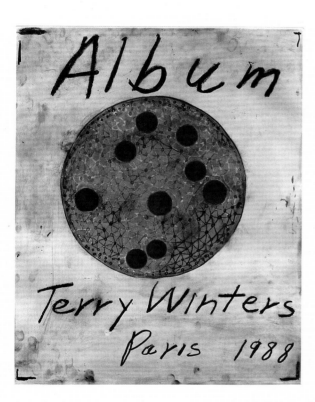

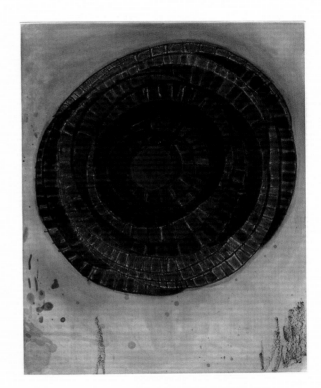

23. Album (2)
Etching, spit bite aquatint, soft ground etching, and
sugar lift aquatint printed in three colors
Proofs: 1 WP, 7 TP

Colors: Tan, gray, black

Printing sequence: Three printings from three plates.
1) tan [spit bite aquatint] 2) gray [soft ground etching]
3) black [etching, soft ground etching, sugar lift
aquatint, and spit bite aquatint]

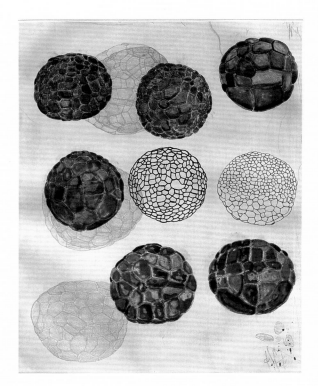

24. Album (3)
Soft ground etching, spit bite aquatint, etching, and
sugar lift aquatint printed in three colors
Proofs: 4 TP

Colors: Gray, brown, black

Printing sequence: Three printings from three plates.
1) gray [soft ground etching and spit bite aquatint]
2) brown [spit bite aquatint] 3) black [etching, sugar
lift aquatint, and spit bite aquatint]

25. Album (4)
Spit bite aquatint and soft ground etching printed in
two colors
Proofs: 3 TP

Colors: Pink, black

Printing sequence: 1) pink [spit bite aquatint] 2) black
[soft ground etching and spit bite aquatint]

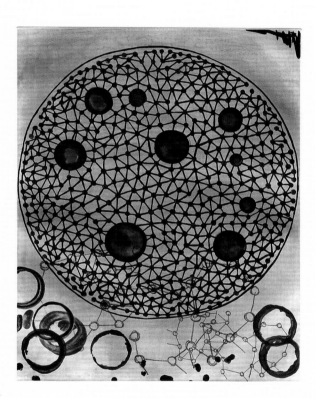

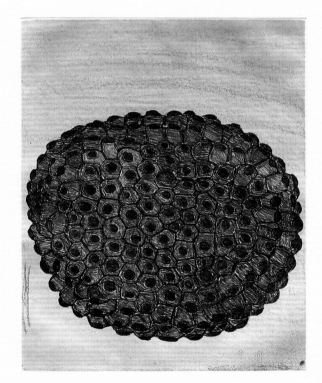

26. Album (5)
Spit bite aquatint and etching printed in two colors
Proofs: 5 TP

Colors: Gray, black

Printing sequence: 1) gray [spit bite aquatint]
2) black [etching and spit bite aquatint]

27. Album (6)
Spit bite aquatint, soft ground etching, and sugar lift
aquatint printed in two colors
Proofs: 3 TP

Colors: Warm gray, cool gray, black

Printing sequence: Three printings from three plates.
1) warm gray [spit bite aquatint] 2) cool gray [spit bite
aquatint] 3) black [soft ground etching, sugar
lift aquatint, and spit bite aquatint]

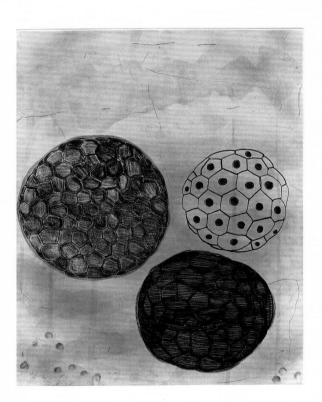

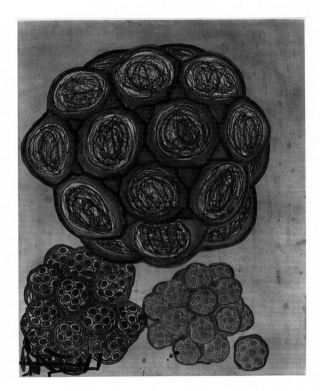

28. Album (7)
Spit bite aquatint and sugar lift aquatint printed
in three colors
Proofs: 1 WP, 2 TP

Colors: Gray, black, white

Printing sequence: Three printings from three plates.
1) gray [spit bite aquatint] 2) black [sugar lift aquatint
and spit bite aquatint] 3) white [sugar lift aquatint and
spit bite aquatint]

29. Album (Colophon)
Soft ground etching, spit bite aquatint, and
photogravure printed in two colors
Proofs: 2 TP

Colors: Gray, black

Printing sequence: 1) gray [soft ground etching and
spit bite aquatint] 2) black [photogravure]

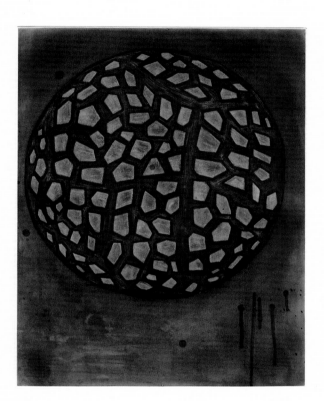

30. Rejected title page from Album 1988

Etching and spit bite aquatint printed in one color on
Hahnemühle paper
Plate: 27.6 x 27 cm (10 7/8 x 10 5/8 in.)
Sheet: 50.8 x 39.3 cm (20 x 15 1/2 in.)
Signed: (*TW*), lower left
Numbered, lower right

Edition: 8 HC
Printer: Atelier Aldo Crommelynck, Paris

Color: Black

Printing sequence: One printing from one plate printed
on an etching press.
Plate preserved for future consideration by the artist.

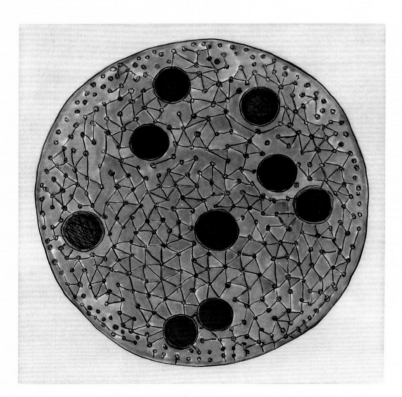

31. Station 1988

Soft ground etching and spit bite aquatint printed
in one color on Torinoko Gampi paper laid down on
J. Whatman 1952 paper
Plate: 40 x 29.8 cm (15 3/4 x 11 3/4 in.)
Sheet: 61.6 x 49.5 cm (24 1/4 x 19 1/2 in.)
Signed (*T Winters*) and dated (*1988*), lower left edge
Numbered, lower right corner
Publisher's drystamp, lower right corner

Edition: 55 plus 7 AP, 2 PP
Proofs: 1 signed BAT, 1 signed TP, 10 signed state
proofs, 1 signing proof
Printer: John Lund
Publisher: ULAE

Color: Black

Printing sequence: One printing from one plate printed
on an etching press.

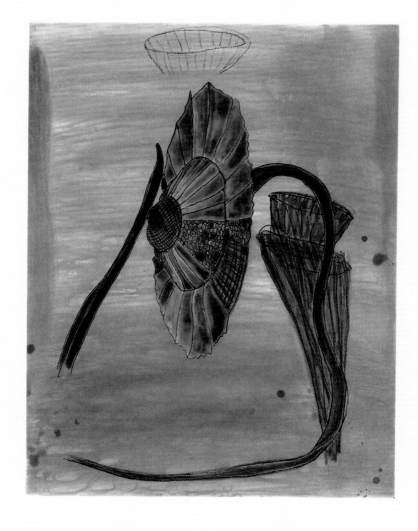

32. Marginalia 1988
Lithograph printed in seven colors on
Arches Cover Stock paper
Image and sheet: 121.9 x 80.6 cm (48 x 31³/₄ in.)
Signed (*TW*) and dated (*1988*), lower right
Numbered, lower right, below signature
Publisher's drystamp, lower left corner

Edition: 66 plus 8 AP, 4 PP
Proofs: 1 signed BAT, 5 signed TP, 2 sets
of color separations
Printers: Keith Brintzenhofe, Douglas Volle
Publisher: ULAE

Colors: Tan, four blacks, graphite, white

Printing sequence: Seventeen printings from seventeen
plates; 1-3 printed on a hand transfer lithographic
press; 4-17 printed on a hand-fed offset lithographic
press. The image was split in half horizontally to
accommodate the press size.
1) tan 2-3) black 4) graphite 5) black 6) white, black
7) black, graphite 8-10) black 11) graphite, white
12-13) black 14) black, white 15-17) black

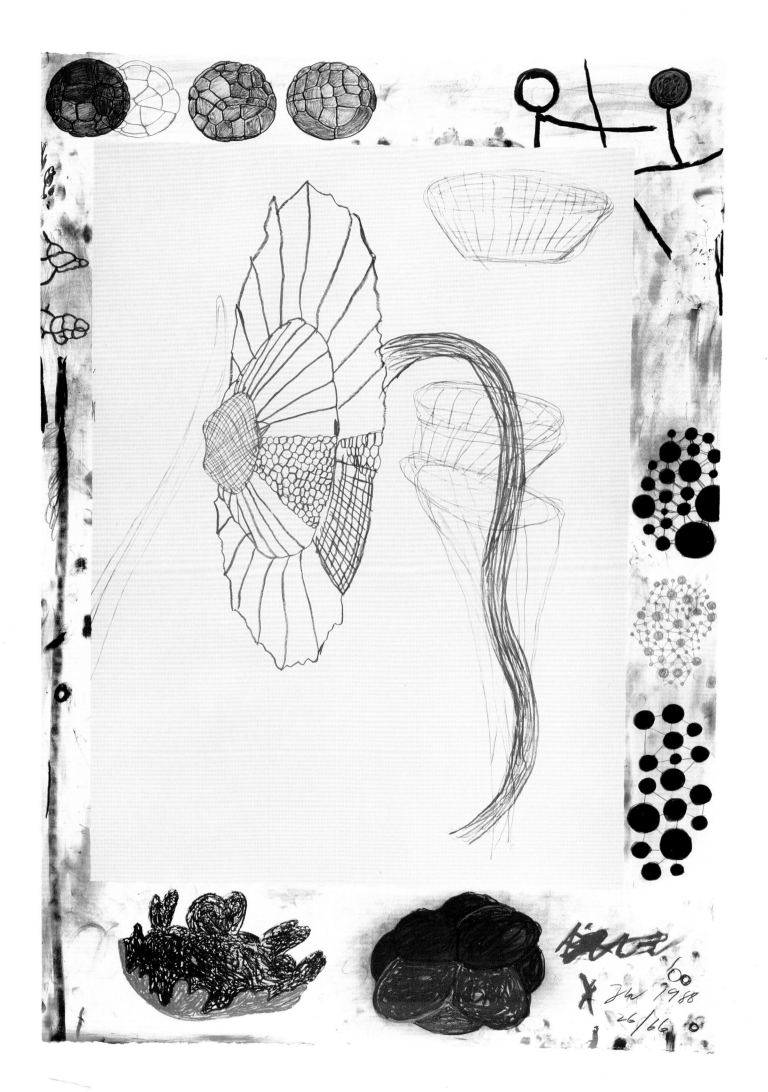

73

33. Untitled 1988
Etching, soft ground etching, and spit bite aquatint
printed in one color on Hahnemühle paper
Plate: 70.5 x 56.5 cm (27 3/4 x 22 1/4 in.)
Sheet: 89.5 x 71.8 cm (35 1/4 x 28 1/4 in.)
Signed (*Terry Winters*), dated (*1988*), and numbered,
center bottom edge
Drystamp, lower right corner:
ALDO/CROMMELYNCK/PARIS

Edition: 50 plus 10 AP, 2 HC, 1 BN
Proofs: 1 BAT, 1 WP, 8 state proofs
Printer: Atelier Aldo Crommelynck, Paris
Publisher: Editions Ilene Kurtz, New York

Color: Black

Printing sequence: One printing from one plate
printed on an etching press.
Plate preserved for future consideration by the artist.

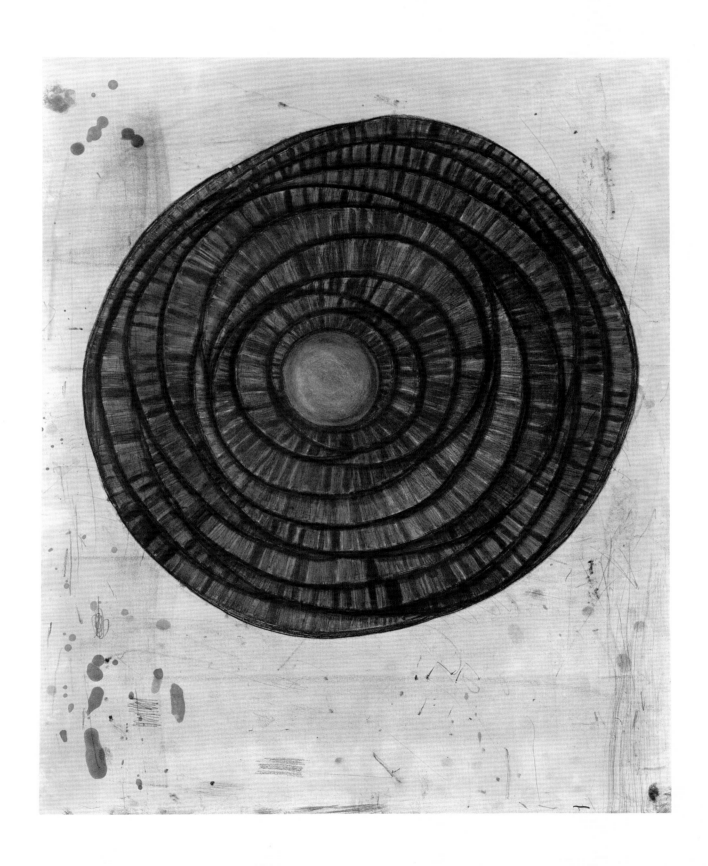

34–47. Fourteen Etchings 1989

Portfolio of fourteen hand-drawn Mylar gravures with various intaglio additions and photogravures printed in one color; the upper plates printed on Torinoko Gampi laid down on paper handmade in Almafi, Italy (torn to size), the lower plates printed on the Amalfi paper

Sheets (irregular): 47.3 x 36 cm (18 5/8 x 14 1/8 in.)

Numbered, signed (*Terry Winters*), and dated (*1989*) on title page, lower center

Signed (*TW*), upper right corner of each sheet

Arabic numeral embossed, lower right corner of each sheet

Publisher's drystamp, lower left corner of each sheet

Publisher's logo printed in black ink, lower right corner of colophon

Edition: 65 portfolios plus 8 AP, 3 PP

Proofs: 2 TP

Printers: Keith Brintzenhofe, John Lund, Hitoshi Kido, with assistance from Tina Diggs

Publisher: ULAE

Color: Black

Printing sequence: With the exception of number 1, which was printed from one plate only, each print made in two printings from two plates on an etching press. Photogravures (lower plates) made from photographs of X-rays used as illustrations in a turn-of-the-century German book of anatomy.

Issued in a five-page, paper folder handmade in Japan and contained in a basswood box (see illustration, facing page, left) made by Frank D'Agostino. Letterpress title printed in black ink on upper center of the folder cover (see illustration, facing page, right). Text selected by Terry Winters from *Roget's International Thesaurus* (New York: Harper and Row Publishers, Inc., 4th edition), printed in black ink on inner cover of the folder (see illustration, page 78). Colophon is a loose sheet also printed in black ink. Typography designed by Roland Aeschlimann and printed by Douglas Volle and Bruce Wankel.

TERRY WINTERS
FOURTEEN
ETCHINGS

ANDROMEDA | ANTLIA PNEUMATICA, THE AIR PUMP | APUS, THE BIRD OF PARADISE | AQUARIUS, THE WATER BEARER | AQUILA, THE EAGLE | ARA, THE ALTAR | ARGO NAVIS, THE SHIP ARGO | ARIES, THE RAM | AURIGA, THE CHARIOTEER | BIG DIPPER, CHARLES' WAIN | BOÖTES, THE HERDSMAN | CAELA SCULPTORIS, THE SCULPTOR'S TOOL | CAMELO PARDUS, THE GIRAFFE | CANCER, THE CRAB | CANES VENATICI, THE HUNTING DOGS | CANIS MAJOR, THE LARGER DOG | CANIS MINOR, THE LESSER DOG | CAPRICORN, THE HORNED GOAT | CARINA, THE KEEL | CASSIOPEIA | CENTAURUS, THE CENTAUR | CEPHEUS, THE MONARCH | CETUS, THE WHALE | CHAMAELEON, THE CHAMELEON | CIRCINUS, THE COMPASSES | COLUMBA NOAE, NOAH'S DOVE | COMA BERENICES, BERENICE'S HAIR | CORONA AUSTRALIS, THE SOUTHERN CROWN | CORONA BOREALIS, THE NORTHERN CROWN | CORVUS, THE CROW | CRATER, THE CUP | CRUX, THE CROSS | CYGNUS, THE SWAN | DELPHINUS, THE DOLPHIN | DORADO, THE DORADO FISH | DRACO, THE DRAGON | EQUULEUS, THE FOAL | ERIDANUS, THE RIVER PO | FORNAX, THE FURNACE | GEMINI, THE TWINS | GRUS, THE CRANE | HERCULES | HOROLOGIUM, THE CLOCK | HYDRA, THE SEA SERPENT | HYDRUS, THE WATER SNAKE | INDUS, THE INDIAN | LACERTA, THE LIZARD | LEO, THE LION | LEO MINOR, THE LESSER LION | LEPUS, THE HARE | LIBRA, THE BALANCE | LITTLE DIPPER | LUPUS, THE WOLF | LYNX, THE LYNX | LYRA, THE LYRE | MALUS, THE MAST | MENSA, THE TABLE | MICROSCOPIUM, THE MICROSCOPE | MONOCEROS, THE UNICORN | MUSCA, THE FLY | NORMA, THE RULE | NORTHERN CROSS | OCTANS, THE OCTANT | OPHIUCHUS, THE SERPENT BEARER | ORION, THE HUNTER | ORION'S BELT | ORION'S SWORD | PAVO, THE PEACOCK | PEGASUS, THE WINGED HORSE | PERSEUS | PHOENIX, THE PHOENIX | PICTOR, THE PAINTER | PISCES, THE FISHES | PISCIS AUSTRALIS, THE SOUTHERN FISH | PUPPIS, THE STERN | RETICULUM, THE NET | SAGITTA, THE ARROW | SAGITTARIUS, THE ARCHER | SCORPIO, THE SCORPION | SCULPTOR, THE SCULPTOR | SCUTUM, THE SHIELD | SERPENS, THE SERPENT | SEXTANS, THE SEXTANT | SOUTHERN CROSS | TAURUS, THE BULL | TELESCOPIUM, THE TELESCOPE | TRIANGULUM, THE TRIANGLE | TRIANGULUM AUSTRALE, THE SOUTHERN TRIANGLE | TUCANA, THE TOUCAN | URSA MAJOR, THE GREAT BEAR | URSA MINOR, THE LESSER BEAR | VELA, THE SAILS | VIRGO, THE VIRGIN | PISCIS VOLANS, THE FLYING FISH | VULPECULA, THE LITTLE FOX

34. Fourteen Etchings 1
Hand-drawn Mylar gravure, sugar lift aquatint,
spit bite aquatint, and scraper
Plate: 20.3 x 16.5 cm (8 x 6 1/2 in.)
Embossed, lower right corner: *1*

35. Fourteen Etchings 2
Hand-drawn Mylar gravure, spit bite aquatint,
and photogravure
Upper plate: 20.3 x 16.8 cm (8 x 6 5/8 in.)
Lower plate: 13.6 x 9.5 cm (5 3/8 x 3 3/4 in.)
Embossed, lower right corner: *2*

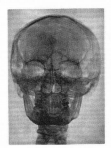

36. Fourteen Etchings 3

Hand-drawn Mylar gravure, spit bite aquatint,
and photogravure
Upper plate: 20.3 x 17.1 cm (8 x 6 ³/₄ in.)
Lower plate: 10.1 x 10.1 cm (4 x 4 in.)
Embossed, lower right corner: *3*

37. Fourteen Etchings 4

Hand-drawn Mylar gravure, spit bite aquatint,
and photogravure
Upper plate: 20.3 x 16.4 cm (8 x 6 ¹/₂ in.)
Lower plate: 14 x 9.3 cm (5 ¹/₂ x 3 ⁵/₈ in.)
Embossed, lower right corner: *4*

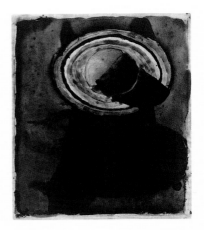

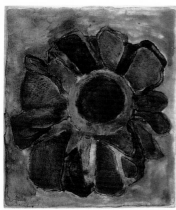

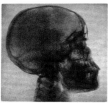

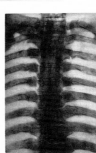

38. Fourteen Etchings 5

Hand-drawn Mylar gravure, open bite etching,
and photogravure
Upper plate: 20 x 16.8 cm (7 7/8 x 6 5/8 in.)
Lower plate: 8.8 x 10.1 cm (3 1/2 x 4 in.)
Embossed, lower right corner: *5*

39. Fourteen Etchings 6

Hand-drawn Mylar gravure, sugar lift aquatint,
and photogravure
Upper plate: 20 x 16.5 cm (7 7/8 x 6 1/2 in.)
Lower plate: 8.8 x 10.1 cm (3 3/4 x 3 1/4 in.)
Embossed, lower right corner: *6*

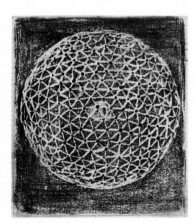

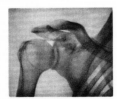

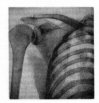

40. Fourteen Etchings 7
Hand-drawn Mylar gravure, spit bite aquatint,
and photogravure
Upper plate: 20.3 x 17.1 cm (8 x 6 3/4 in.)
Lower plate: 9.2 x 6.3 cm (3 5/8 x 2 1/2 in.)
Embossed, lower right corner: *7*

41. Fourteen Etchings 8
Hand-drawn Mylar gravure, spit bite aquatint,
and photogravure
Upper plate: 20.3 x 16.8 cm (8 x 6 5/8 in.)
Lower plate: 12.7 x 6.6 cm (5 x 2 5/8 in.)
Embossed, lower right corner: *8*

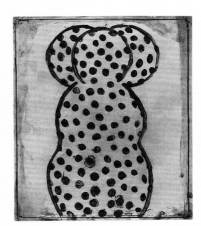

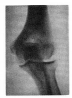

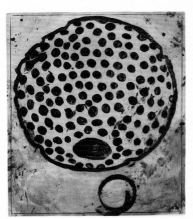

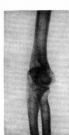

42. Fourteen Etchings 9
Hand-drawn Mylar gravure, sugar lift aquatint,
spit bite aquatint, and photogravure
Upper plate: 20.3 x 16.8 cm (8 x 6 5/8 in.)
Lower plate: 10.5 x 7.9 cm (4 1/8 x 3 1/8 in.)
Embossed, lower right corner: *9*

43. Fourteen Etchings 10
Hand-drawn Mylar gravure, soft ground etching,
spit bite aquatint, and photogravure
Upper plate: 20.6 x 17.4 cm (8 1/8 x 6 7/8 in.)
Lower plate: 13.3 x 9.1 cm (5 1/4 x 3 9/16 in.)
Embossed, lower right corner: *10*

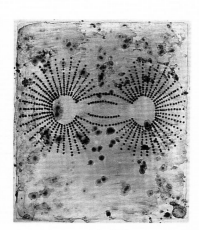

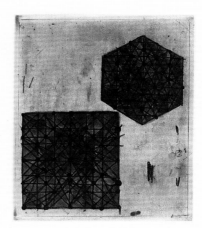

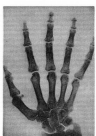

44. Fourteen Etchings 11

Hand-drawn Mylar gravure, spit bite aquatint,
and photogravure
Upper plate: 20.3 x 17.1 cm (8 x 6 3/4 in.)
Lower plate: 14 x 9.8 cm (5 1/2 x 3 7/8 in.)
Embossed, lower right corner: *11*

45. Fourteen Etchings 12

Hand-drawn Mylar gravure, spit bite aquatint,
and photogravure
Upper plate: 20.3 x 16.8 cm (8 x 6 5/8 in.)
Lower plate: 12.7 x 8.8 cm (5 x 3 7/16 in.)
Embossed, lower right corner: *12*

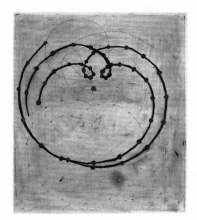

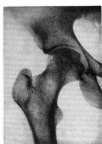

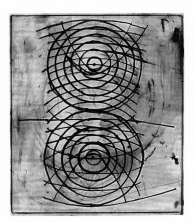

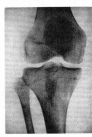

46. Fourteen Etchings 13

Hand-drawn Mylar gravure, open bite etching,
and photogravure
Upper plate: 19.7 x 16.5 cm (7⁷/₈ x 6¹/₂ in.)
Lower plate: 13.6 x 8.8 cm (5³/₈ x 3¹/₂ in.)
Embossed, lower right corner: *13*

47. Fourteen Etchings 14

Hand-drawn Mylar gravure, spit bite aquatint,
and photogravure
Upper plate: 20.3 x 16.8 cm (8 x 6⁵/₈ in.)
Lower plate: 14 x 6.9 cm (5¹/₂ x 2¹¹/₁₆ in.)
Embossed, lower right corner: *14*

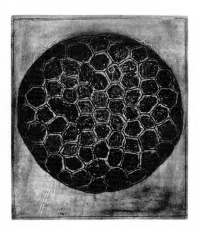

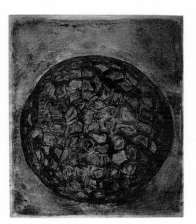

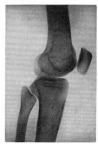

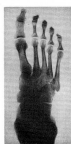

48. Novalis 1983-89

Etching, open bite etching, and aquatint printed in one color on Arches En Tout Cas paper (torn to size)
Plate: 94.6 x 67.9 cm (37 1/4 x 26 3/4 in.)
Sheet: 108 x 78.7 cm (42 1/2 x 31 in.)
Signed (*Terry Winters*) and dated (*1983/89*), lower center
Numbered, lower left
Publisher's drystamp, lower right corner

Edition: 50 plus 10 AP, 3 PP
Proofs: 2 signed BAT, 3 signed TP, 6 unsigned archival proofs
Printers: Keith Brintzenhofe, John Lund, Jihong Shi
Publisher: ULAE

Color: Blue

Printing sequence: One printing from one plate printed on an etching press.

Note: This image was first drawn as a lithograph. One signed TP and one signed WP exist in that medium printed in black ink.

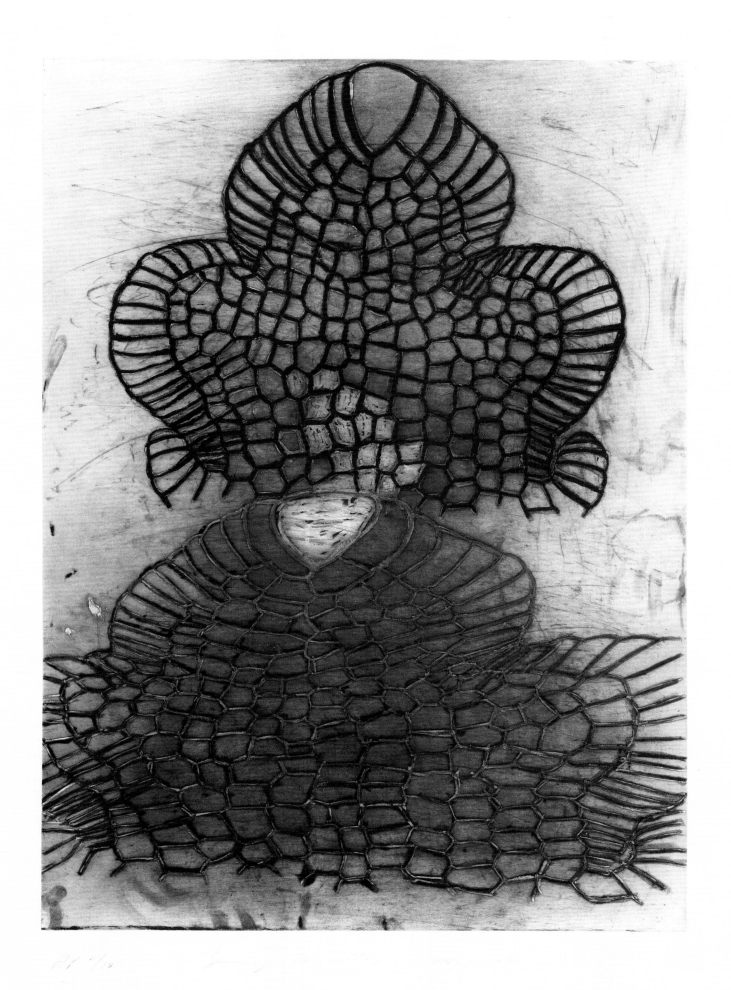

49–53. Furrows 1989

Portfolio of five woodcuts printed in one color
on CartaLafranca paper
Blocks: 64.3 x 49.5 cm (25 $5/16$ x 19 $1/2$ in.)
Sheets (irregular): 67.3 x 54 cm (26 $1/2$ x 21 $1/4$ in.)
Signed (*T Winters*) and numbered, lower left
of each image including colophon
Roman numeral inscribed, lower right of each image

Edition: 45 portfolios (numbered 1-45) plus 12 AP
(numbered I-XII), 2 HC
Proofs: 1 TP set (in an incomplete folder) plus
various additional proofs listed accordingly for
the individual prints
Printer: François Lafranca, Verscio, Switzerland
Publisher: Peter Blum Edition, New York

Color: Transparent black

Printing sequence: Each image made in two printings
from two blocks. Unscored oak block printed with its
grain running vertically, mahogany block carrying
the image printed with its grain running horizontally.

Issued in a handmade three-page paper folder
(see illustration, facing page, left) designed by the
artist with the cover printed from an unscored block
with grain running horizontally and overprinted
in dark gray with letterpress title. An unscored block
with grain running vertically printed on the inner
cover of the folder (see illustration, facing page, right).
The inside center page of the folder printed from an
unscored block with grain running horizontally,
overprinted in letterpress with colophon information
(see illustration, page 90). The folder contained
in a cardboard box constructed by Roland Meuter,
Ascona, Switzerland. The typography designed
by Roland Aeschlimann, Geneva.

TERRY WINTERS

FURROWS

PETER BLUM EDITION

FURROWS

A PORTFOLIO OF FIVE WOODCUTS BY TERRY WINTERS

THE BLOCKS WERE ENGRAVED AND PROOFED AT ATELIERS

LAFRANCA VERSCIO SWITZERLAND

EDITION OF FORTY-FIVE NUMBERED 1-45 PLUS TWELVE

ARTISTS PROOFS NUMBERED I-XII

PRINTED BY FRANÇOIS LAFRANCA ON CARTALAFRANCA

EACH PORTFOLIO CONTAINS FIVE WOODCUTS SIGNED AND

NUMBERED BY THE ARTIST

THE PRINTS WITH THE TITLE AND COLOPHON ARE

INCLUDED IN A HAND-MADE PAPER FOLDER DESIGNED

BY THE ARTIST

THE PRINTS WITH THE FOLDER ARE CONTAINED

IN A CARDBOARD BOX CONSTRUCTED

BY ROLAND MEUTER ASCONA

TYPOGRAPHY DESIGNED

BY ROLAND AESCHLIMANN GENEVA

PUBLISHED BY PETER BLUM EDITION NEW YORK 1989

49. Furrows I
Inscribed, lower right: *I*
Proofs: 3 TP from a rejected block

50. Furrows II
Inscribed, lower right: *II*

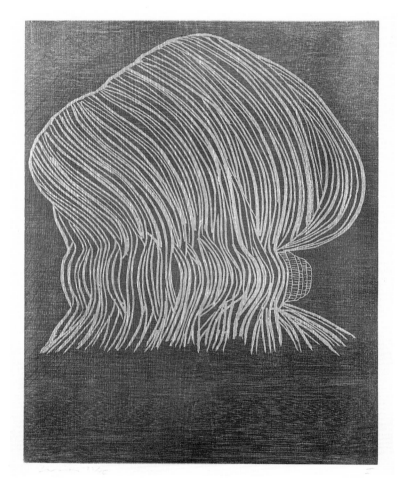

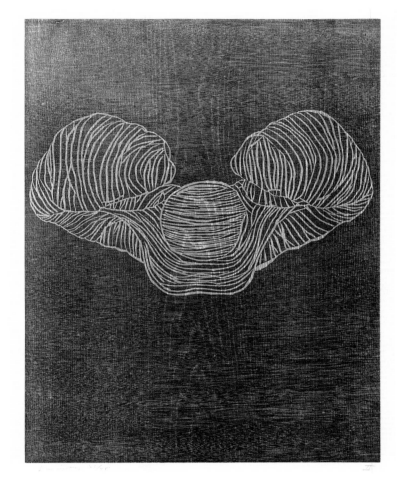

51. Furrows III
Inscribed, lower right: *III*

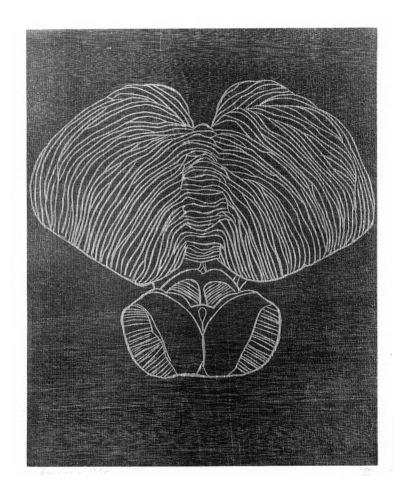

52. Furrows IV
Inscribed, lower right: *IV*
Proofs: 2 TP from a rejected block

53. Furrows V
Inscribed, lower right: *V*
Proofs: 1 WP, 4 TP from rejected blocks

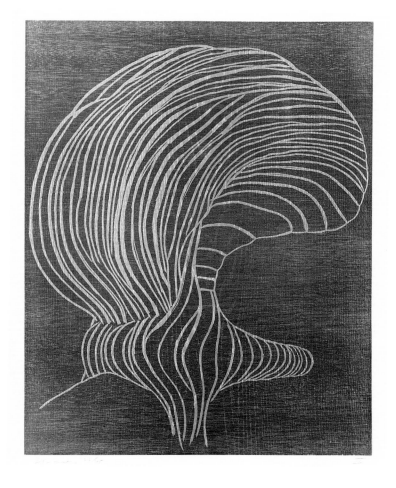

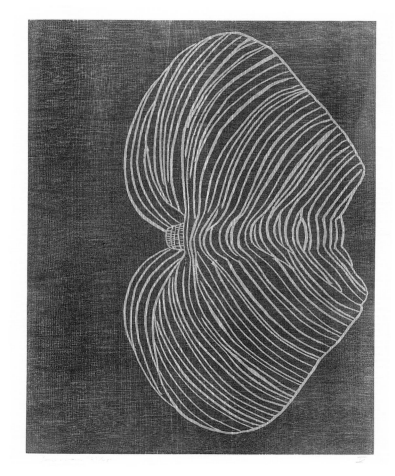

54. Untitled 1989-90
Frontispiece for the book *Terry Winters Fourteen Drawings / Fourteen Etchings,* with text by David Shapiro
Hand-drawn Mylar gravure and open bite etching printed in one color on Torinoko Gampi laid down on wove paper
Plate: 20.3 x 16.8 cm (8 x 6 ⅝ in.)
Sheet/page: 27 x 20.9 cm (10 ⅝ x 8¼ in.)
Signed (*Terry Winters*) and numbered on facing page, lower center
Publisher's drystamp on facing page, lower right corner

Edition: 50 bound books (20 numbered in Arabic numerals, 20 numbered in Roman, and 10 HC numbered in Arabic)
Proofs: 2 TP
Printer: Hitoshi Kido (at ULAE)
Publisher: Verlag Fred Jahn, Munich, and ULAE

Color: Black

Printing sequence: One printing from one plate printed on an etching press.

Note: The book contains both English and German texts, full-size reproductions of fourteen drawings on Mylar by Terry Winters used for *Fourteen Etchings*, and reproductions of the complete portfolio *Fourteen Etchings*, including the colophon.
See cat. nos. 34-47, *Fourteen Etchings*

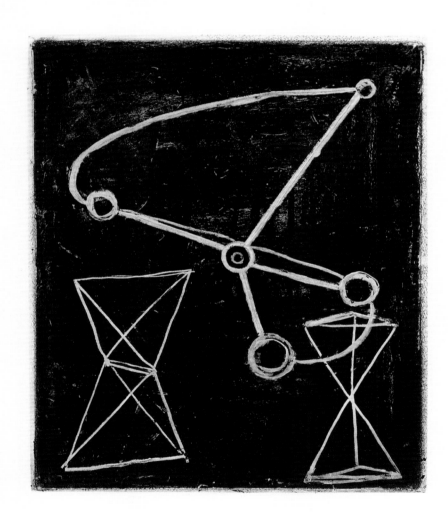

55. After a Lost Original 1991
Frontispiece for the book of the same title by
David Shapiro
Open bite etching printed in two colors on
Twinrocker laid paper
Plate: 18.7 x 13.9 cm (7 3/8 x 5 1/2 in.)
Sheet/page: 23.5 x 18.4 cm (9 1/4 x 7 1/4 in.)
Signed (*Terry Winters*), lower center of the colophon
Signed (*David Shapiro*), center right edge of the
colophon

Edition: 100 bound books, plus 20 AP numbered
in Roman numerals, and 2 PP
Proofs: 1 BAT, 1 TP
Printer: Nancy Mesenbourge
Publisher: Solo Press, New York

Colors: Yellow, black

Printing sequence: One printing from one plate
charged with two colors (second color was rolled
onto the plate after it was charged with the first color)
printed on an etching press.

Note: Book printed at Solo Press by Anne Noonan
Elliot and Peter Kruty in Univers monotype cast at
A. Colish. Text paper custom made at Twinrocker, Inc.
in 18th-century cream with endsheets of buff Moriki.
Paste papers handmade by Rebecca Lax at Solo Press.
Book and slipcase bound by Claudia Cohen.
Publication edited by Christopher Sweet.

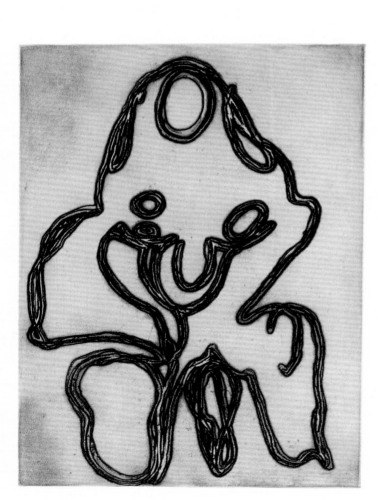

56. Untitled (Whitney) 1991
Hand-drawn Mylar gravure, etching, sugar lift
aquatint, spit bite etching, and open bite etching
printed in two colors on Mulberry paper laid down
on J. Whatman 1956 paper
Plate: 27.3 x 30.5 cm (10 3/4 x 12 in.)
Sheet (irregular): 34.9 x 43.8 cm (13 3/4 x 17 1/4 in.)
Signed (*TWinters*) and dated (*1991*), upper
right corner
Numbered, lower right corner
Publisher's drystamp, lower left corner

Edition: 100 plus 25 AP, 3 PP
Proofs: 1 WP, 7 TP, 1 signing proof
Printers: Keith Brintzenhofe, John Lund, Bruce Wankel
Publisher: ULAE

Colors: Yellow, black

Printing sequence: Two printings from two plates
printed on an etching press.
1) yellow 2) black

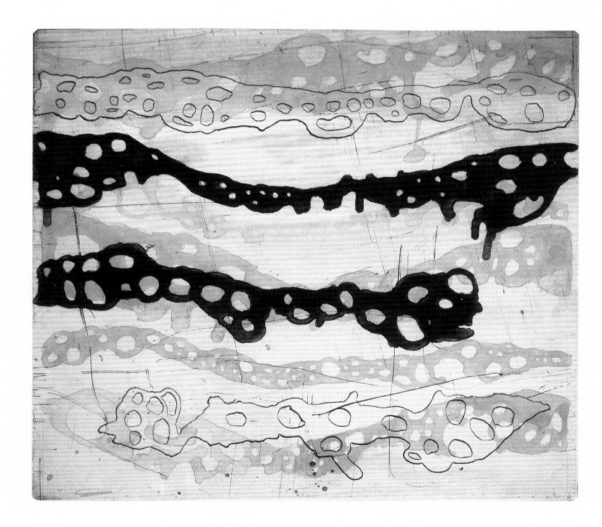

57. Section 1991

Lithograph printed in four colors on Torinoko paper
Image and sheet: 151.1 x 101.6 cm (59 $\frac{1}{2}$ x 40 in.)
Signed (*Terry Winters*) and dated (*1991*), upper center
Numbered, upper right
Publisher's drystamp, lower left

Edition: 68 plus 10 AP, 2 PP
Proofs: 4 signed TP on various papers, 3 unsigned archival proofs
Printers: Keith Brintzenhofe, Douglas Volle
Publisher: ULAE

Colors: Proofing black, noir à monter, writing black, opaque white

Printing sequence: Fifteen printings from three stones and twelve plates; 1-4 printed on a hand transfer lithographic press; 5-15 printed on a hand-fed offset lithographic press.
1-3) proofing black, noir à monter [from stones]
4-14) writing black 15) white

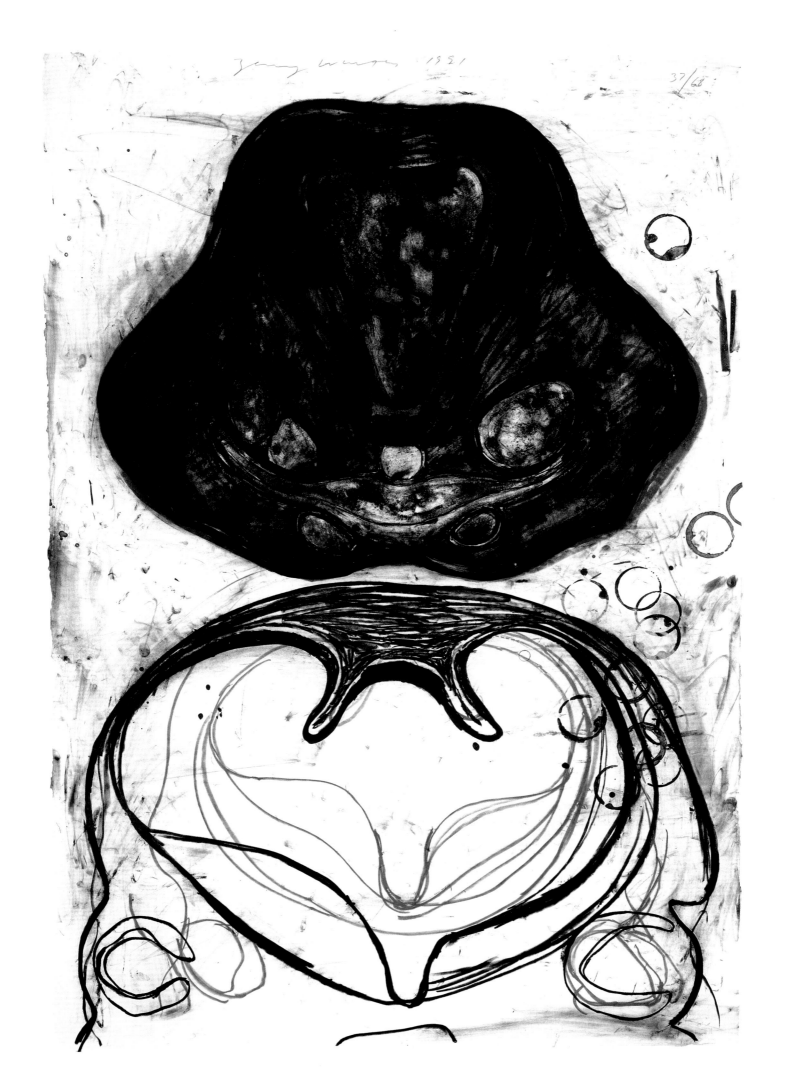

58–63. Primitive Segments 1991

Portfolio of six screenprints, including title page, printed in color on Echizen-Kizuki-Hosho handmade paper
Images and sheets (irregular): 58.4 x 47 cm (23 x 18½ in.)
Signed and numbered in varying locations on each sheet; also numbered on the folder, lower right
Dated on the title page
Publisher's drystamp in varying locations on each sheet

Edition: 70 portfolios plus 10 AP, 3 PP, 6 HC
Proofs: 1 RTP
Printers: Hiroshi Kawanishi, Kenjro Nonaka, Mitsunobu Sugiura, Tokyo
Publisher: Simca Print Artists, New York, and Terry Winters

Issued in a heavyweight three-page japan paper folder (see illustration, this page) stamped in red ink, lower right of folder cover: *TERRY WINTERS/ PRIMITIVE SEGMENTS/SIMCA PRINT ARTISTS.* Colophon information printed on the inside of the folder.

Note: Encaustic inks were used in this portfolio; powdered charcoal, graphite, and white pigments were mixed with beeswax.

45/70

58. Primitive Segments, Title Page

Signed (*Terry Winters*) and dated (*1991*), lower left
Numbered, lower right
Title printed, upper center:
TERRY WINTERS/PRIMITIVE/SEGMENTS
Publisher's name printed, lower center:
SIMCA PRINT ARTISTS
Publisher's drystamp, lower right corner

Colors: Charcoal, graphite

Printing sequence: Seven printings in two colors
printed from seven screens. Letters on this page printed
from photoscreens in the first two printings.
1) charcoal 2-7) graphite

59. Primitive Segments, I

Signed (*TW*), upper left corner
Numbered, below signature
Inscribed, upper right corner: *I*
Publisher's drystamp, lower right corner

Color: Graphite

Printing sequence: Six printings in one color from
six screens.

60. Primitive Segments, II
Signed (*TW*), lower right corner
Numbered, below signature
Inscribed, upper right corner: *II*
Publisher's drystamp, lower right corner

Colors: Zinc white, graphite

Printing sequence: Eleven printings in two colors
from eleven screens.
1-2) zinc white 3-11) graphite

61. Primitive Segments, III
Signed (*TW*) and numbered, upper left
Inscribed, upper right corner: *III*
Publisher's drystamp, lower left corner

Color: Graphite

Printing sequence: Eleven printings in one color
from eleven screens.

11. Terry Winters, <u>Primitive Segments</u>, 1991

62. Primitive Segments, IV

Signed (*TW*) and numbered, lower left
Inscribed, upper right corner: *IV*
Publisher's drystamp, lower right corner

Colors: Graphite, charcoal

Printing sequence: Twelve printings in
two colors from twelve screens.
1-5) graphite 6) charcoal 7-12) graphite

63. Primitive Segments, V

Signed (*TW*) and numbered, lower right corner
Inscribed, upper right corner: *V*
Publisher's drystamp, lower right corner

Colors: Graphite, zinc white, charcoal

Printing sequence: Ten printings in three
colors from ten screens.
1-2) graphite 3) zinc white 4) graphite
5) charcoal 6-10) graphite

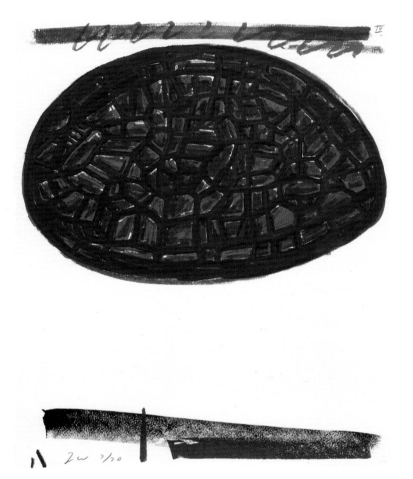

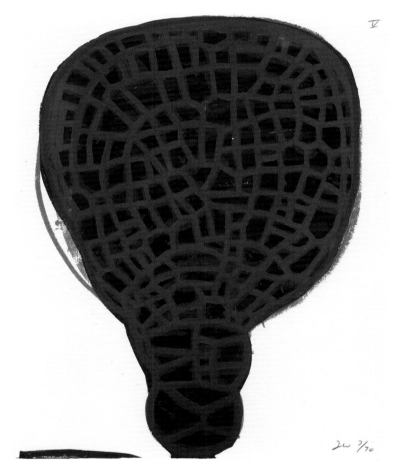

64–69. Small Segments 1991
Set of six lithographs printed in two colors on
wove paper
Sheets: 28.8 x 22.2 cm (11³/₈ x 8³/₄ in.)
Each sheet individually signed, numbered, and
dated, in varying locations
Inscribed in Arabic numerals in blue pencil,
upper right of each sheet

Edition: 3 complete HC sets
Printer: Douglas Volle

Printing sequence: All prints made from two plates.

Note: Prints are variations of the images used in
Primitive Segments (cat. nos. 58-63).

64. Small Segments, 1
Signed (*TW*) and numbered, upper right
Dated (*1991*), upper right corner
Inscribed, upper right: *1*

Colors: Two blacks

65. Small Segments, 2
Signed (*TW*) and numbered, upper right
Dated (*1991*), upper right corner
Inscribed, upper right: *2*

Colors: Black, white

66. Small Segments, 3
Signed (*TW*) and numbered, upper right
Dated (*1991*), upper right corner
Inscribed, upper right: *3*

Colors: Two blacks

67. Small Segments, 4
Signed (*TW*) and numbered, upper right
Dated (*1991*), upper right
Inscribed, upper right: *4*

Colors: Two blacks

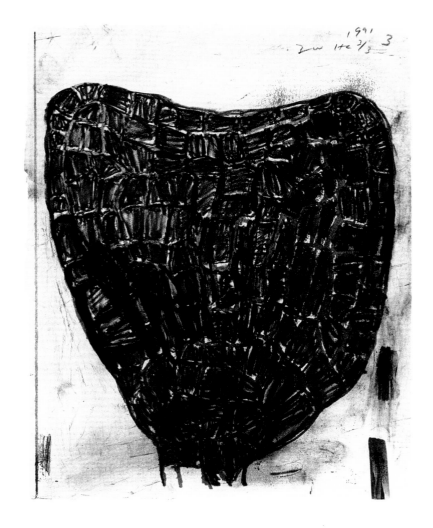

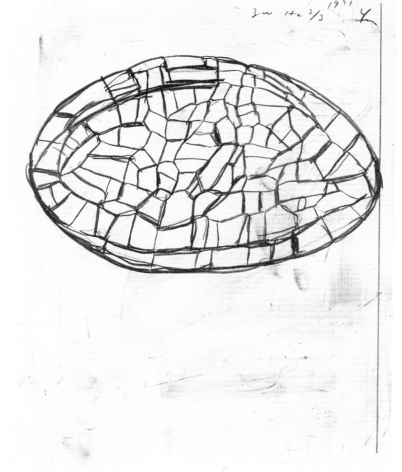

68. Small Segments, 5
Signed (*TW*) and numbered, upper left
Dated (*1991*), upper right corner
Inscribed, upper right: *5*

Colors: Two blacks

69. Small Segments, 6
Signed (*TW*), upper left
Numbered, below signature
Dated (*1991*), upper right
Inscribed, upper right: *6*

Colors: Two blacks

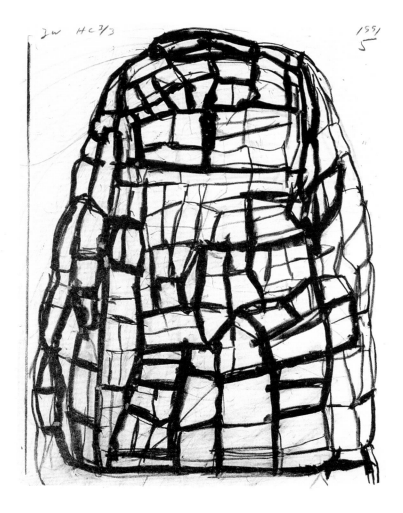

70. Theorem 1992
Lithograph printed in eighteen colors on Arches
Cover Stock paper
Image and sheet: 80.6 x 122.2 cm (31³/₄ x 48¹/₈ in.)
Signed (*T Winters*), lower left
Dated (*1992*), below signature
Numbered, lower right
Publisher's drystamp, lower left corner

Edition: 41 plus 12 AP, 2 PP
Proofs: 1 TP, 2 sets of progressive proofs, 2 sets
of color separations
Printers: Bill Goldston, Douglas Volle
Publisher: ULAE

Colors: Purple, red, blue, brown, black, yellow,
gray, green (a total of eighteen colors were mixed
from these eight)

Printing sequence: Eighteen printings from
eighteen plates; 1-6 printed on a hand transfer
lithographic press and 7-18 printed on a hand-fed
offset lithographic press.
1) purple 2) red 3) purple 4-5) blue 6) brown
7) black 8) purple 9) red, brown 10-11) blue
12-13) yellow 14) gray 15) green 16) yellow 17) green
18) red, green

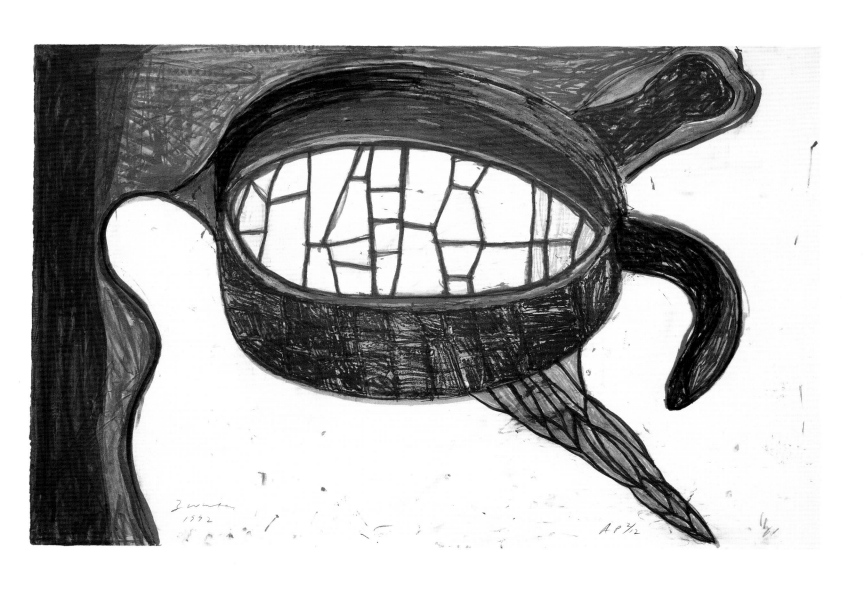

71–95. Field Notes 1992

Portfolio of twenty-five intaglio prints printed in
one color on Hahnemühle paper
Plates: 21.6 x 15.9 cm (8 ¹/₂ x 6 ¹/₄ in.)
Sheets: 33 x 25.4 cm (13 x 10 in.)
Signed (*T Winters*), lower left corner of each sheet
Numbered, lower right corner of each sheet and
lower left, verso

Edition: 75 portfolios numbered 1-75, 15 AP
numbered AP I/XV-XV/XV, 15 PP numbered PP I/XV-
XV/XV, 5 portfolios for collaborators, 1 BN
Proofs: 1 BAT, 2 TP (one set annotated by the artist)
plus various additional proofs listed accordingly for
the individual prints
Printer: Atelier Aldo Crommelynck, Paris
Publisher: Aldo Crommelynck, Paris

Color: Black

Printing sequence: Each image made in one printing
from one plate on an etching press.

Issued in a paper folder contained in a brown paper-
covered paperboard box (see illustration, facing page,
left) manufactured by Bernard Duval. Title printed in
letterpress on front cover and side of the box.
Colophon printed in letterpress on a loose sheet.
Typographic design by François Da Ros.
Plates preserved for future consideration by the artist.

72. Field Notes, 2
Sugar lift aquatint, spit bite aquatint, open bite
etching, and scraper
Proofs: 1 TP

73. Field Notes, 3
Etching
Proofs: 1 TP

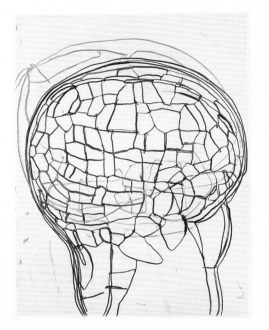

74. Field Notes, 4
Open bite etching and spit bite aquatint
Proofs: 1 TP

75. Field Notes, 5
Soft ground etching

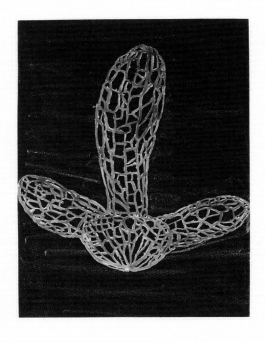

76. Field Notes, 6
Etching, sugar lift aquatint, and spit bite aquatint
Proofs: 2 TP

77. Field Notes, 7
Sugar lift aquatint and spit bite aquatint
Proofs: 4 TP

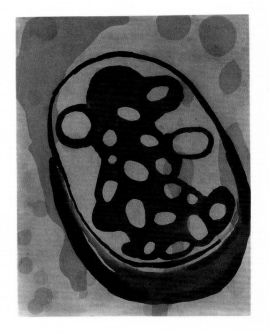

78. Field Notes, 8
Soft ground etching

79. Field Notes, 9
Etching, sugar lift aquatint, and spit bite aquatint
Proofs: 6 TP

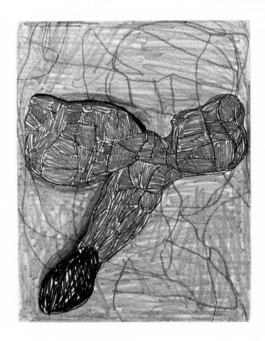

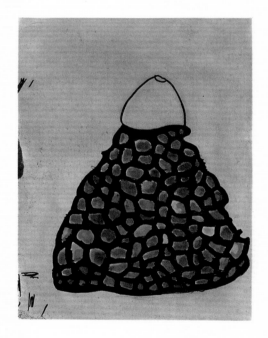

80. Field Notes, 10
Etching
Proofs: 4 TP

81. Field Notes, 11
Etching, open bite etching, sugar lift aquatint, and
spit bite aquatint
Proofs: 1 WP, 3 TP

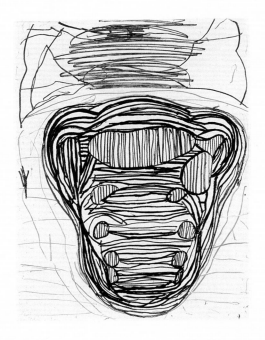

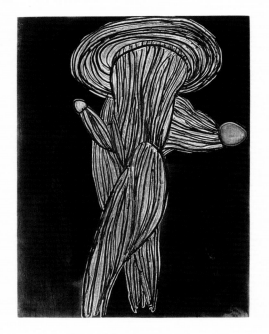

82. Field Notes, 12
Etching, sugar lift aquatint, and spit bite aquatint
Proofs: 1 TP

83. Field Notes, 13
Etching and spit bite aquatint
Proofs: 1 TP

84. Field Notes, 14
Etching, sugar lift aquatint, and spit bite aquatint
Proofs: 2 TP

85. Field Notes, 15
Etching, sugar lift aquatint, and spit bite aquatint
Proofs: 2 TP

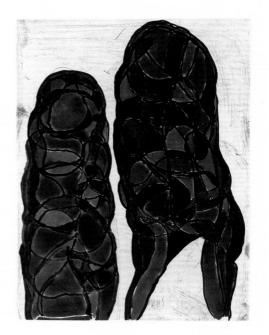

86. Field Notes, 16
Etching, sugar lift aquatint, spit bite aquatint, and
open bite etching
Proofs: 1 TP

87. Field Notes, 17
Sugar lift aquatint and spit bite aquatint
Proofs: 1 TP

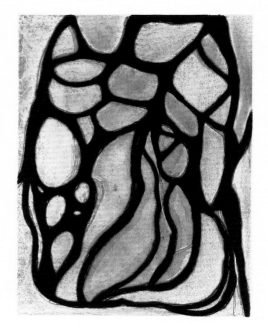

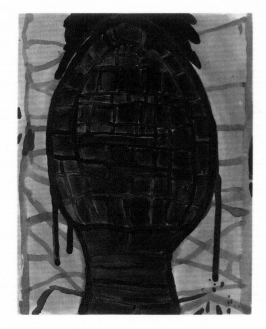

88. Field Notes, 18
Soft ground etching
Proofs: 1 TP

89. Field Notes, 19
Sugar lift aquatint, spit bite aquatint, and open bite etching
Proofs: 1 WP, 5 TP

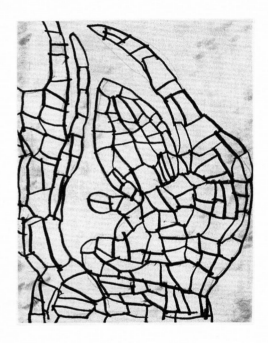

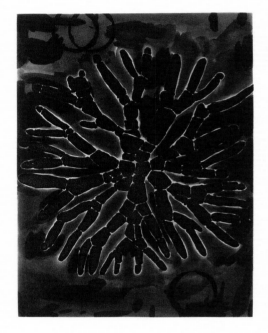

90. Field Notes, 20
Sugar lift aquatint and spit bite aquatint
Proofs: 3 TP

91. Field Notes, 21
Etching
Proofs: 1 TP

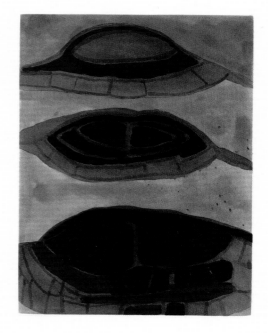

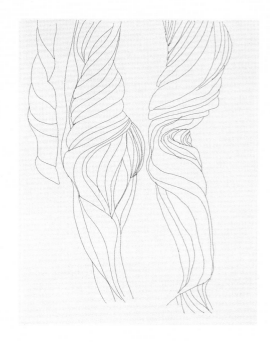

92. Field Notes, 22
Sugar lift aquatint, spit bite aquatint, and
open bite etching
Proofs: 4 TP

93. Field Notes, 23
Etching, soft ground etching, spit bite aquatint,
and sugar lift aquatint
Proofs: 4 TP

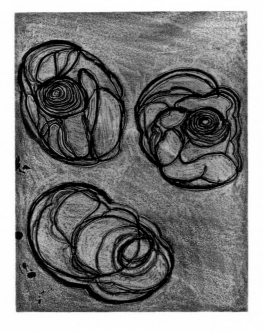

94. Field Notes, 24
Soft ground etching and spit bite aquatint
Proofs: 2 TP

95. Field Notes, 25
Etching, spit bite aquatint, and drypoint
Proofs: 2 TP

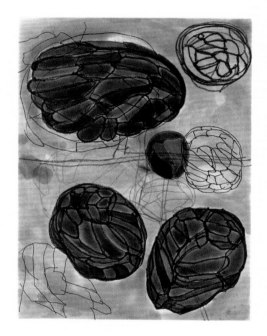

96. Locus 1993
Lithograph printed in eight colors on Arches
Cover Stock paper
Image and sheet (irregular): 63.2 x 90.8 cm
(24 $^7/_8$ x 35 $^3/_4$ in.)
Signed (*Terry Winters*) and dated (*1993*) in
image, upper right
Numbered, lower left corner
Publisher's drystamp, lower right corner

Edition: 49 plus 10 AP, 3 PP
Proofs: 1 WP, 4 TP, 8 plate separations printed
in black only
Printers: Bill Goldston, Douglas Volle, Bruce Wankel
Publisher: ULAE

Colors: Orange, blue, green, purple, yellow, black,
red, white

Printing sequence: Fifteen printings from eleven
plates printed on a hand-fed offset lithographic press.
1) orange 2) blue [same plate as 1] 3) green
4) purple 5) yellow 6) orange 7) blue 8) red 9) black
10) orange 11) blue [same plate as 10] 12-15) white
[12 and 13 from one plate; 14 and 15 from one plate]

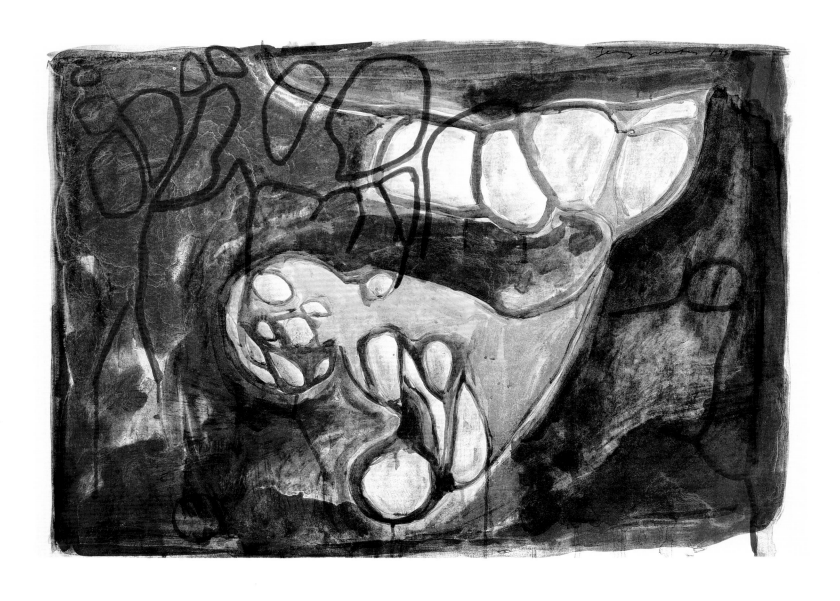

97–108. Models for Synthetic Pictures 1994

Portfolio of twelve intaglio prints, each combining open bite etching, soft ground etching, sugar lift aquatint, and spit bite aquatint printed in five colors on Gampi paper laid down on Lana Gravure (torn to size)
Plates: 34.3 x 41.9 cm (13 1/2 x 16 1/2 in.)
Sheets (irregular): 49.2 x 56.5 cm (19 3/8 x 22 1/4 in.)
Signed (*Terry Winters*) and dated (*1994*), lower right edge of each sheet
Numbered, lower left corner of each sheet
Publisher's drystamp, lower right corner of each sheet
Publisher's logo printed in black ink, center right edge of the colophon

Edition: 35 portfolios plus 9 AP, 4 PP
Proofs: 1 BAT, 3 TP plus various additional proofs listed accordingly for the individual prints
Printers: Hitoshi Kido, John Lund, Nancy Mesenbourg, Ji Hong Shi
Publisher: ULAE

Colors: Red, yellow, blue, two blacks

Printing sequence: Unless otherwise indicated, each print made in five printings from five plates on an etching press. The color sequence was yellow, red, blue, and two variations of black. Sugar lift and spit bite aquatint printed from the yellow, red, and blue plates. Soft ground and open bite etching printed from the black plates.

Issued in a three-page Lana Gravure paper folder (see illustration, this page) printed from six plates on a flat-bed offset lithographic press by Bruce Wankel with title printed in black ink on a solid rectangle of blue (13 $^5/_8$ x 17 in.) on the cover of the folder. Text (see illustration, page 128) by Terry Winters printed in black ink on a solid rectangle of red on the inner cover of the folder. Colophon (see illustration, page 129) information printed in black ink on a solid rectangle of yellow on the inside of the center page of the folder. Folder contained in a dark blue, silk-covered paperboard portfolio (see illustration, page 126) made by Cyobido in Japan.

TERRY WINTERS
MODELS FOR SYNTHETIC PICTURES

MODELS FOR SYNTHETIC PICTURES

1. Systems, a graphic architecture Drawing must be stored as an abstract. Functionally, as images which use world coordinates. When a device forms the viewpoint or the viewing angle a plane representation results. Light sources as well as the object are specified as a set of transformations takes place. The flattened projection is mapped onto the plane.

2. Surfaces, level These so-called level surfaces are usually represented as variable events—as points in space which assume given values. Trace out the surface equations.

3. Modeling space, methods of representation The choices are stated. Describing a given object is a trade-off. Different provisions are needed to maintain more than one level of abstraction. The most useful or appropriate for each picture is chosen as the defining principle. Consistent operations are performed, providing a program which promotes understanding.

4. Enveloping magnetic field, manifold objects For purposes of input, consider the existing picture as a translation of modeled intersections, or a calculation of stresses and distances. Graphic display paths offer the detection of more and more emotional properties. Painting provides a convenient method for significant data compression—controling precisely the shape of the synthesized dimension.

5. Iterated functions, randomly chosen methods A great enough number of iterations will compact the painting. An attractor map computes the distribution marks arranged according to the following theorem: every picture is associated with a unique, balanced measure which is its stationary probability.

6. Levels, studied complexities Current geometries measure and analyze visual events. Now a shape is said to be a special function which stimulates various existing objects. Classical representation fails to describe such functions, which appear frequently in nature.

7. The rate of color change, the rate of transparency Transformation parameters change the rate of magnitude and allow the representation of dynamic phenomena. The sample drawing needs more structured display and other applications. Development consists in allowing pictures to be independent of each other. A procedural system for picture generation. Gravity allows picture movement to be modified. Realistic effects can be added as each application needs definition.

8. Pictures, availability Drawing is produced through collaboration. Painting visualizes a feedback loop whose interactive construction is the picture's ergonomics. Produced by suitable three-dimensional action the animated scene is already a realistic view. The picture renders the richness of input.

9. Light rays, trajectories of Locate the optical center of the observer. Trace from this impact point and draw. After a certain depth, the final color is produced. A ray-traced image is designed and obtained by these procedures.

10. Sweep representations, translational Structures are represented as vectors of parallel surfaces. The painted object is a plane parallel. A painting's use is as a method of input, a constructive, independent representation.

11. Operations, delineations Express complex functions and emotions. The usual terminology is used for describing various painting construction techniques. These terms are also a means of understanding when exact language is applied to illustrated sets. We, ourselves, are representation models supported by some finite graph or net. The structure of the net will vary depending on the information stored at the nodes of the net.

12. Hidden dimensions, determination Each picture is indexed by eye-space. The painting process uses intuitive order as color intersects the bounding edges. Images are displayed and assigned rendering techniques. Picture systems with diffuse and specular components are chosen. The solution consists in drawing sophisticated shading models which use ambient shadows.

COLOPHON

Models for Synthetic Pictures is a portfolio of twelve intaglios with a text by Terry Winters. Published in an edition of thirty-five with nine artist's proofs and four printer's proofs, the portfolio is presented in a box which was custom made in Japan by Cyobido.

Each of the twelve prints is numbered in the lower left corner and signed and dated in the lower right corner of the sheet. The publisher's seal is embossed to the right of the date.

Fifty-seven printings were made from fifty-seven copper plates by Hitoshi Kido, John Lund, Nancy Mesenbourg and Ji Hong Shi on an etching press. The folder was printed from six aluminum plates by Bruce Wankel on a flatbed offset lithographic press. All plates were cancelled after printing.

The paper is Gampi, laid down on Lana Gravure hand torn to 19 3/8 X 22 1/4 in. (49.2 X 56.5 cm). The paper for the folder is Lana Gravure.

Published and printed by Universal Limited Art Editions, 5 Skidmore Place, West Islip, New York 11795 USA. All rights reserved.

97. Models for Synthetic Pictures, 1

Proofs: 3 TP, 7 initialed archival proofs

Printing sequence: Four printings from four plates.
1) yellow, red 2) blue 3-4) black

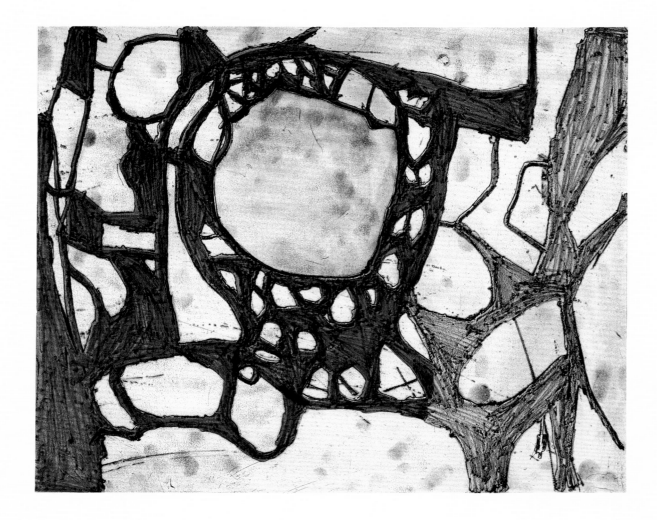

TP 1/3

Terry Winters 1994

98. Models for Synthetic Pictures, 2
Proofs: 1 WP, 1 TP, 1 initialed archival proof

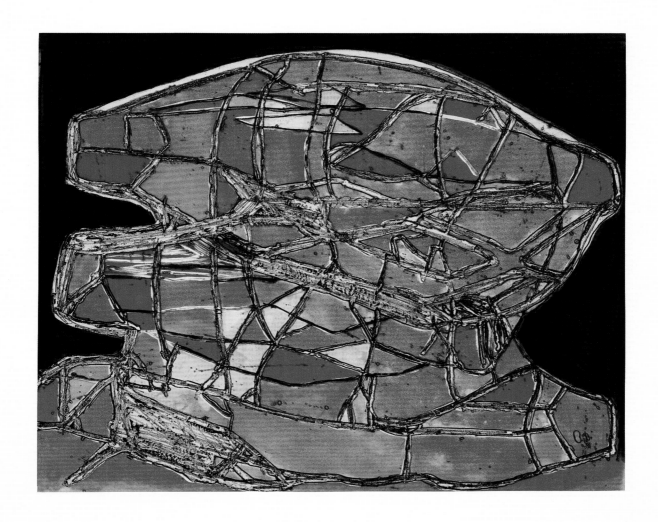

TP 1/3 Jörg Immendorff 1994

99. Models for Synthetic Pictures, 3
Proofs: 2 WP, 2 TP, 3 initialed archival proofs

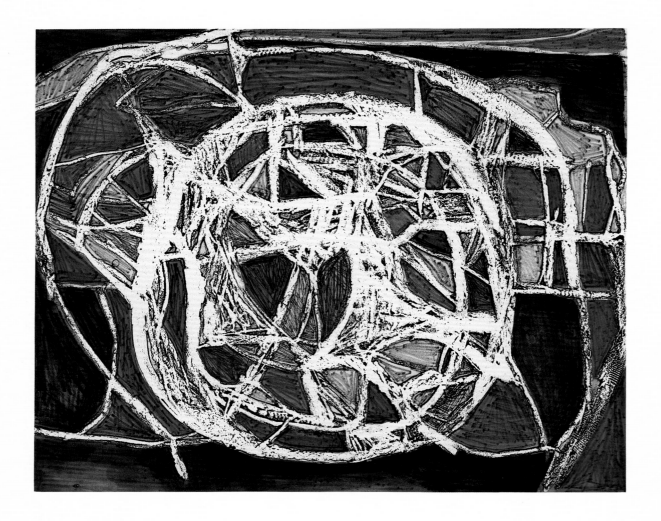

TP 1/3

100. Models for Synthetic Pictures, 4
Proofs: 2 WP, 4 TP, 9 initialed archival proofs

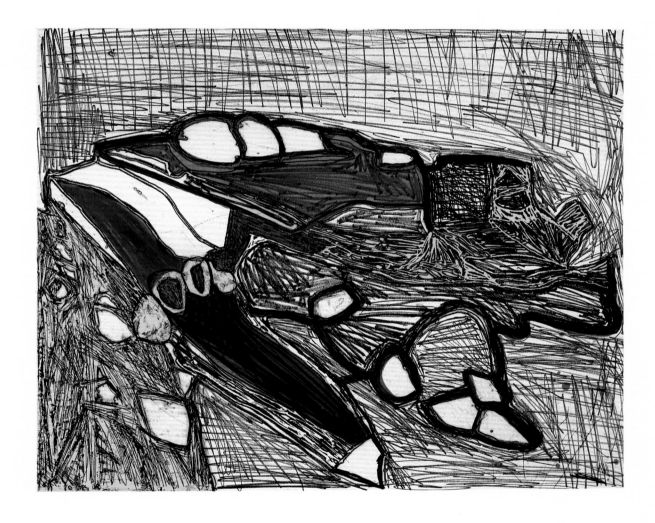

TP 1/2

133

101. Models for Synthetic Pictures, 5
Proofs: 1 TP, 2 initialed archival proofs

Printing sequence: Three printings from three plates.
1) yellow, blue, red 2-3) black

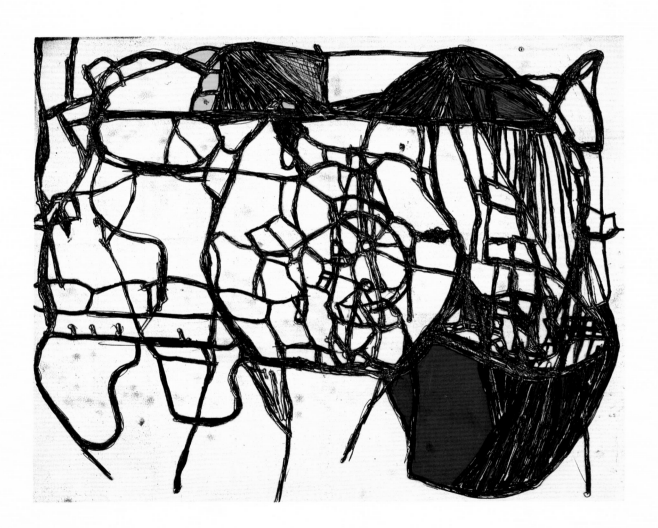

TP 1/3 Jerry Walter 1994

102. Models for Synthetic Pictures, 6
Proofs: 4 TP, 2 initialed archival proofs

Note: The inks used for this print were diluted
versions of the same inks used for all the other prints
in the portfolio.

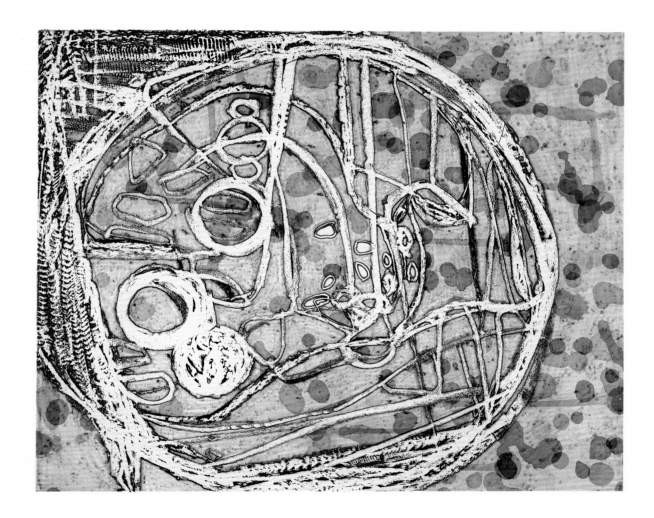

TP 1/3

103. Models for Synthetic Pictures, 7
Proofs: 1 WP, 1 TP, 3 initialed archival proofs

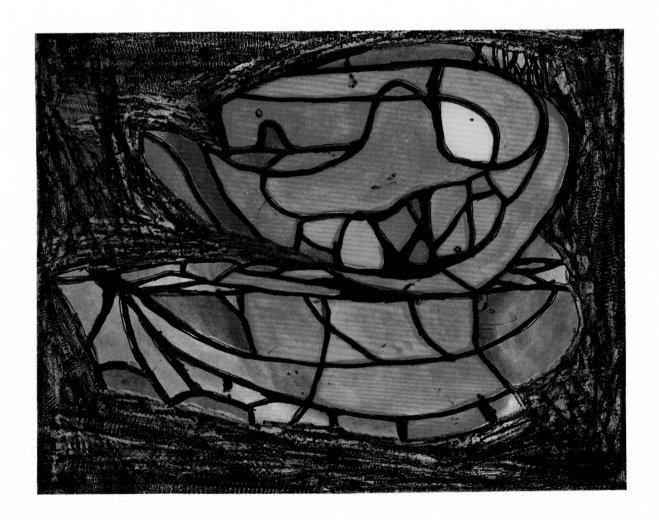

TP 1/2

104. Models for Synthetic Pictures, 8
Proofs: 1 WP, 10 TP, 2 initialed archival proofs

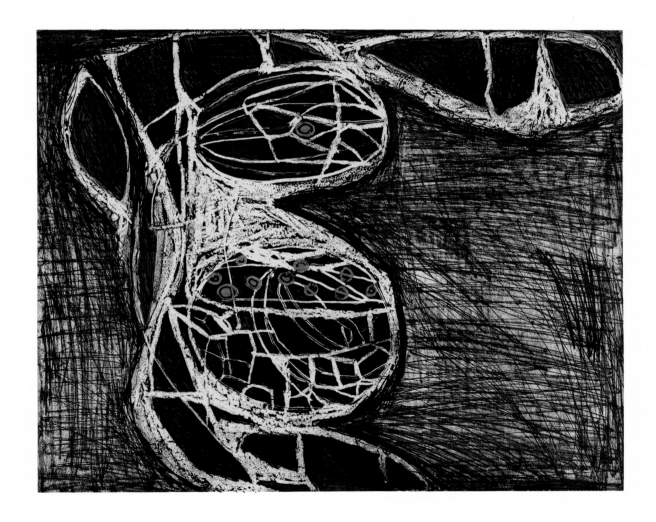

TP 1/3

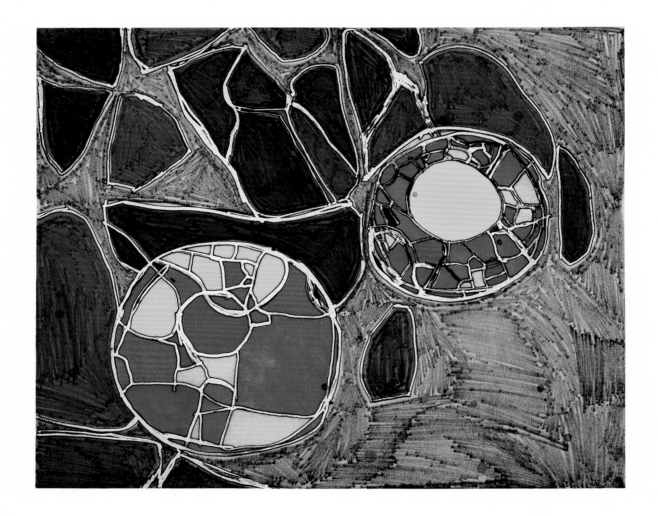

TP 1/3 1994

106. Models for Synthetic Pictures, 10
Proofs: 1 WP, 6 TP, 1 initialed archival proof

Printing sequence: Four printings from four plates.
1) yellow, blue 2) red 3-4) black

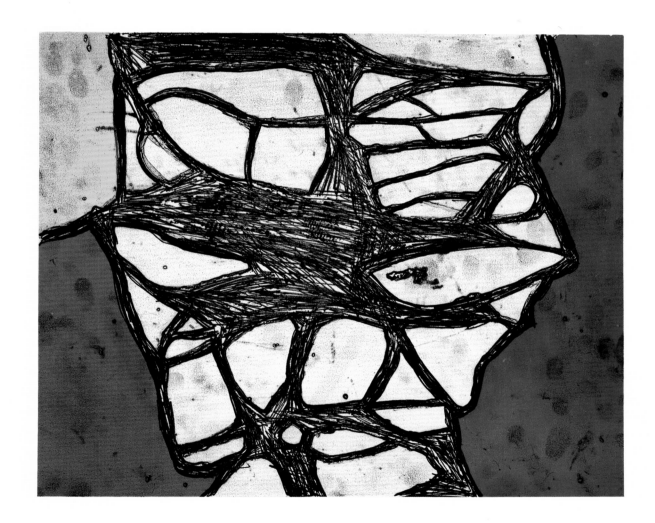

TP 1/3

Terry Winters 1994

107. Models for Synthetic Pictures, 11
Proofs: 2 TP, 1 initialed archival proof

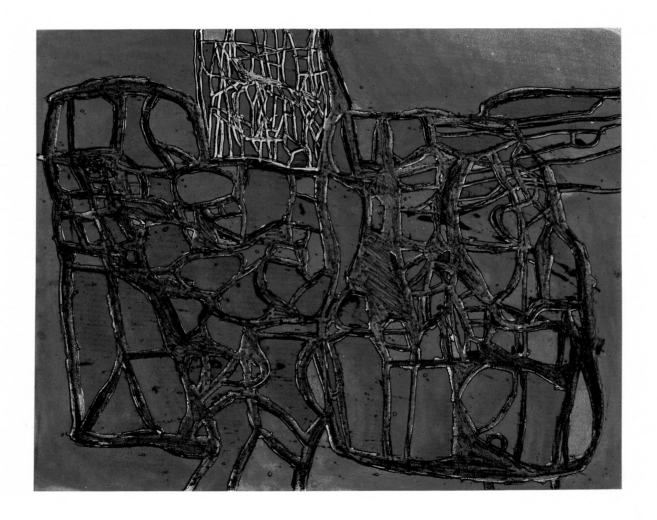

TP 1/3

108. Models for Synthetic Pictures, 12
Proofs: 2 TP, 1 initialed archival proof

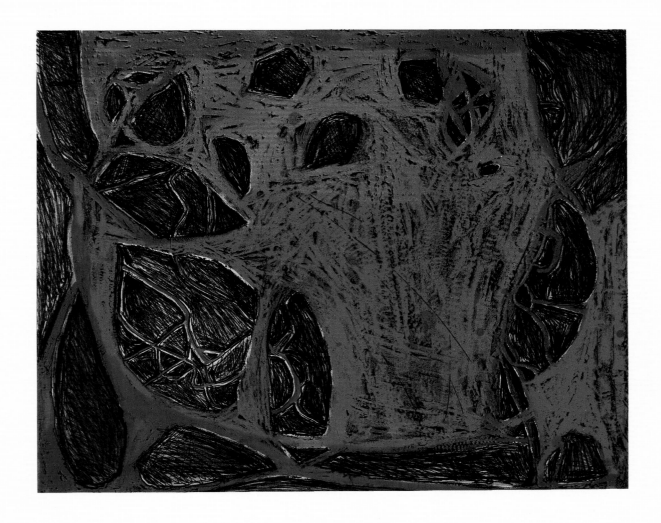

TP 1/2

Terry Winters 1994

109. Chaos 1994

Open bite etching, etching, spit bite aquatint,
and lithograph printed in one color on wove paper
Plate: 42.6 x 55.6 cm (16 ³/₄ x 21 ⁷/₈ in.)
Sheet: 50.8 x 66.6 cm (20 x 26 ¹/₄ in.)
Signed and dated (*TW 94*), lower right
Numbered, lower left
Publisher's drystamp, lower left

Edition: 5 HC
Proofs: 3 TP (one of which is printed in blue ink)
Printer: Hitoshi Kido
Publisher: ULAE

Color: Black

Printing sequence: Two printings from two plates.

Note: CHAOS is an acronym for Caliditas, Humiditas,
Algor, Occulta Siuitas (Heat, Moisture, Cold, Hidden
Dryness).

C H A O S

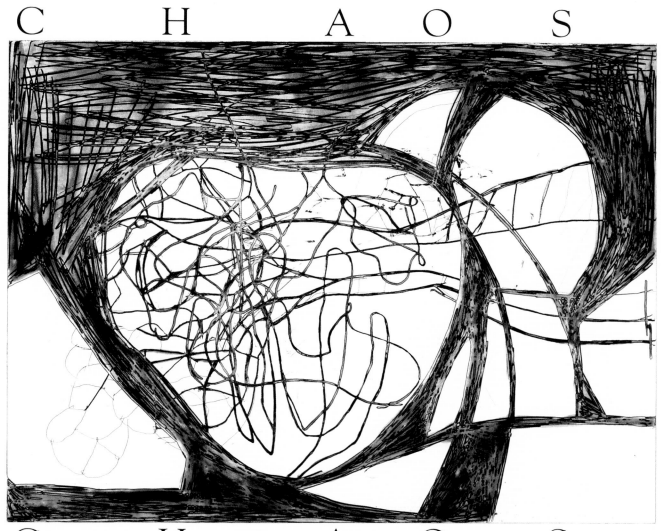

Caliditas Humiditas Algor Occulta Siuitas

110–115. Glyphs 1995

Portfolio of six linoleum cuts printed in one color on Sekishu paper hand dyed with indigo
Sheets (irregular): 61.3 x 44.1 cm (24 1/8 x 17 3/8 in.)
Signed (*Terry Winters*), lower left of folder cover
Numbered, lower center of folder cover
Dated (*1995*), lower right corner of folder cover
Signed (*Terry Winters*) in blue pencil, lower left of each sheet
Edition number in red pencil, lower center of each sheet
Inscribed in Arabic numerals in red pencil, lower right of each sheet
Publisher's drystamp, lower right of folder cover

Edition: 27 portfolios plus 6 AP, 2 PP, 1 HC
Proofs: 5 TP plus various additional proofs listed accordingly for the individual prints
Printer: Leslie Miller
Publisher: The Grenfell Press, New York

Color: Black

Printing sequence: Each image printed from one block on a Vandercook relief proofing press.

Issued in a paper folder with title printed on papier collé, lower right of folder cover (see illustration, this page).

110. Glyphs, 1
Block: 58.1 x 42.8 cm (22 $^7/_8$ x 16 $^7/_8$ in.)
Inscribed, lower right: *1*

111. Glyphs, 2
Block: 57.8 x 42.8 cm (22 $^3/_4$ x 16 $^7/_8$ in.)
Inscribed, lower right: *2*

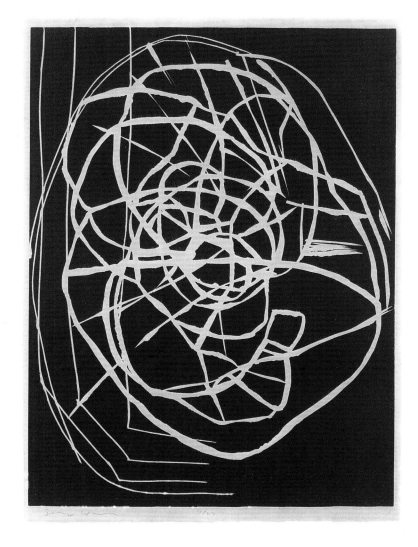

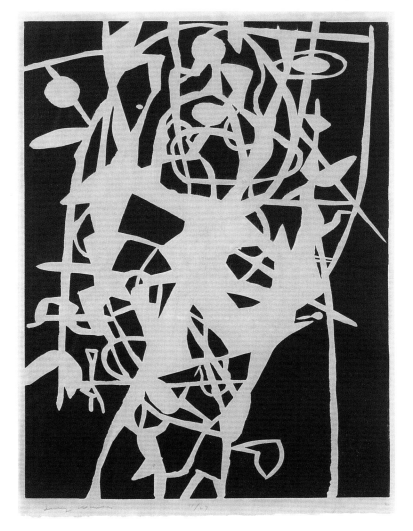

112. Glyphs, 3
Block: 58.1 x 41.2 cm (22 7/8 x 16 1/4 in.)
Inscribed, lower right: *3*
Proofs: 1 BAT, 4 HC printed in cadmium red dark
against a solid ground of cadmium red light on
Kurotani Kozo paper

113. Glyphs, 4
Block: 57.9 x 42.8 cm (22 13/16 x 16 7/8 in.)
Inscribed, lower right: *4*
Proofs: 1 TP printed in dark blue indigo dye

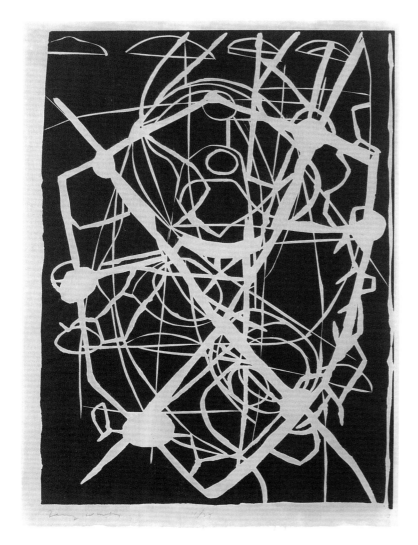

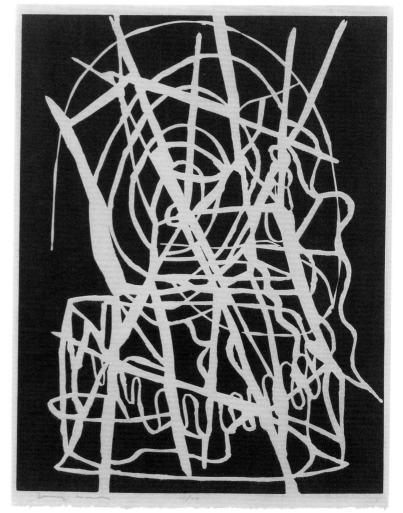

114. Glyphs, 5
Block: 58.1 x 42.8 cm (22 7/8 x 16 7/8 in.)
Inscribed, lower right: *5*

115. Glyphs, 6
Block: 57.8 x 40.6 cm (22 3/4 x 16 in.)
Inscribed, lower right: *6*

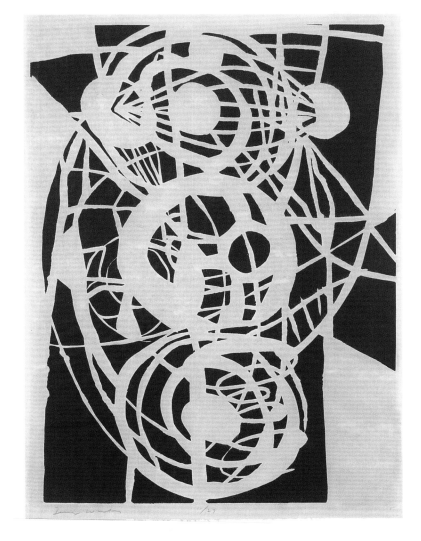
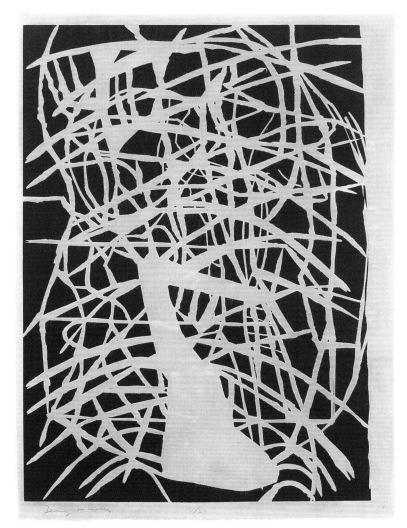

12. Terry Winters, <u>Glyphs</u>, 1995

116. Vorticity Field 1995

Soft ground etching, sugar lift aquatint, spit bite
aquatint, and scraper printed in six colors on
Hahnemühle paper
Plate: 56.5 x 76.2 cm (22 ¼ x 30 in.)
Sheet: 74.9 x 91.4 cm (29 ½ x 36 in.)
Signed (*Terry Winters*) and dated (*1995*), lower right
Numbered, lower left
Publisher's drystamp, lower left corner:
ALDO/CROMMELYNCK

Edition: 50 plus 6 AP, 2 PP, 1 BN
Proofs: 1 BAT, 9 WP, 8 TP of various states
Printer: Atelier Aldo Crommelynck, Paris
Publisher: Aldo Crommelynck, Paris

Colors: Cobalt blue, light blue, green, ultra blue,
violet, gray

Printing sequence: Five printings from five plates on an
etching press.
1) cobalt blue 2) light blue 3) green 4) ultra blue
5) violet, gray
Plates preserved for future consideration by the artist.

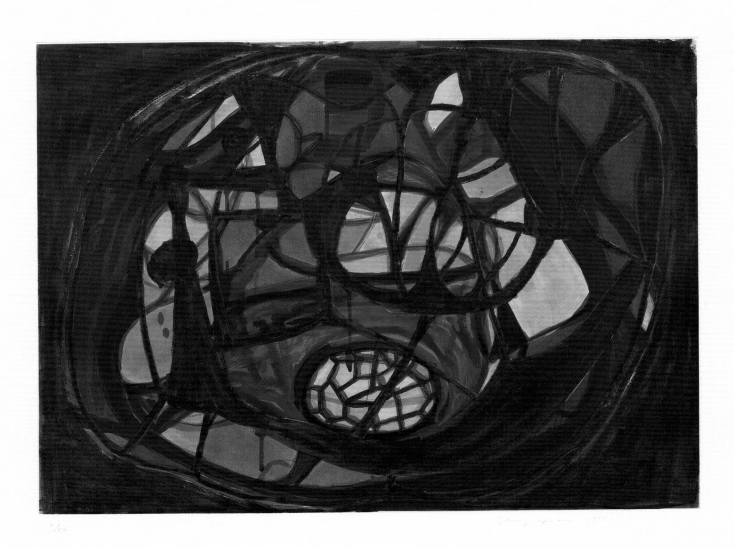

117. Potential Surface of Density 1996

Open bite etching, sugar lift aquatint, aquatint, and scraper printed in one color on Hahnemühle paper
Plate: 29.5 x 39.4 cm (11⅝ x 15½ in.)
Sheet: 46 x 53.6 cm (18⅛ x 21⅛ in.)
Signed (*TWinters*) and dated (*1996*), lower right
Numbered, lower left
Publisher's drystamp, lower right corner:
ALDO/CROMMELYNCK

Edition: 30 plus 4 AP, 1 HC, 1 BN
Proofs: 1 BAT, 1 WP, 5 TP
Printer: Atelier Aldo Crommelynck, Paris
Publisher: Aldo Crommelynck, Paris

Color: Black

Printing sequence: One printing from one plate printed on an etching press.
Plate preserved for future consideration by the artist.

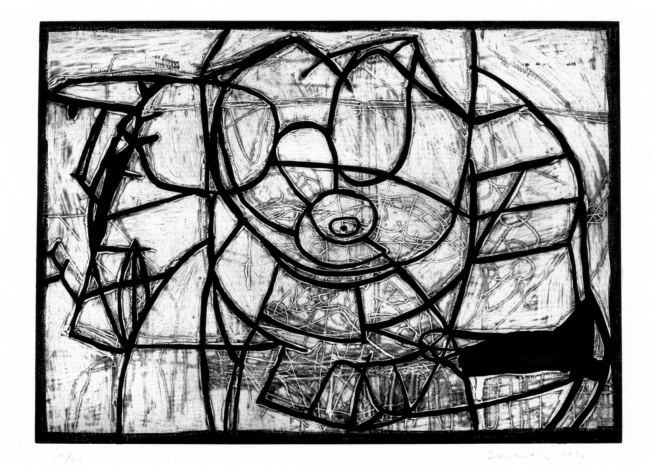

118. Systems Diagram 1996
Etching, soft ground etching, and sugar lift aquatint printed in one color on Arches En Tout Cas paper (torn to size)
Plate: 85.7 x 107.3 cm (33 ³/₄ x 42 ¹/₄ in.)
Sheet: 106.7 x 127 cm (42 x 50 in.)
Signed (*Terry Winters*) and dated (*1996*), upper right
Numbered, upper left
Publisher's drystamp, upper left corner

Edition: 18 plus 7 AP, 3 PP
Proofs: 1 BAT, 5 TP
Printers: Lorena Salcedo-Watson, Scott Smith, Craig Zammiello
Publisher: ULAE

Color: Black

Printing sequence: One printing from one plate printed on an etching press.
Plate preserved for future consideration by the artist.

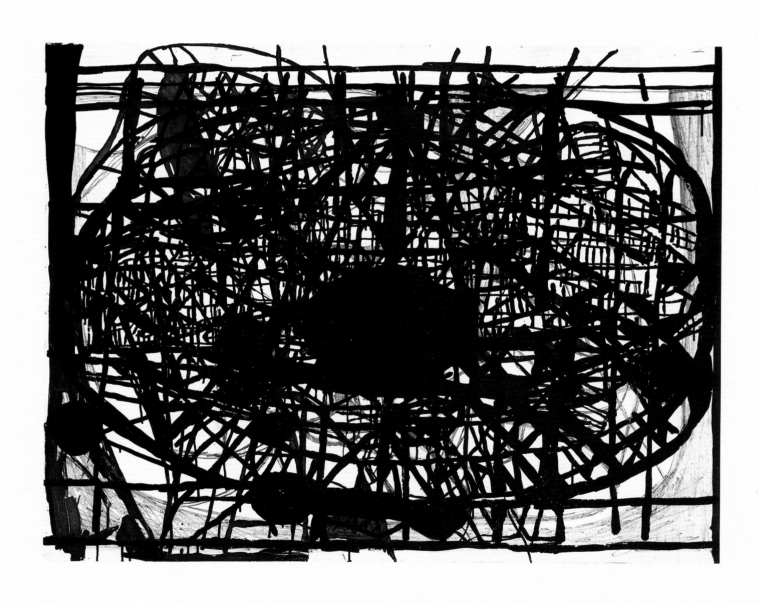

119. Untitled 1996
Lithograph printed in ten colors on BFK Rives paper
(torn to size)
Image and sheet: 85.7 x 121.9 cm (33 3/4 x 48 in.)
Signed (*Terry Winters*), dated (*1996*), and
numbered, upper left
Publisher's drystamp, lower left corner

Edition: 48 plus 10 AP, 3 PP
Proofs: 3 TP, 4 initialed archival proofs
Printers: Doug Bennett, Douglas Volle, Bruce Wankel
Publisher: ULAE

Colors: Yellow, standard orange, monastral red,
proofing black, flag red, rose red, writing black,
vermillion, velvet black, and a tenth color made by
mixing rose red and proofing black

Printing sequence: Fourteen printings from fourteen
plates printed on a hand-fed offset lithographic press.
1) yellow 2) standard orange 3-4) monastral red
5) proofing black 6) flag red 7) rose red 8) mix of
rose red and proofing black 9) yellow 10) writing
black 11) vermillion 12) mix of rose red and proofing
black 13) velvet black 14) mix of rose red and
proofing black
Plates preserved for future consideration by the artist.

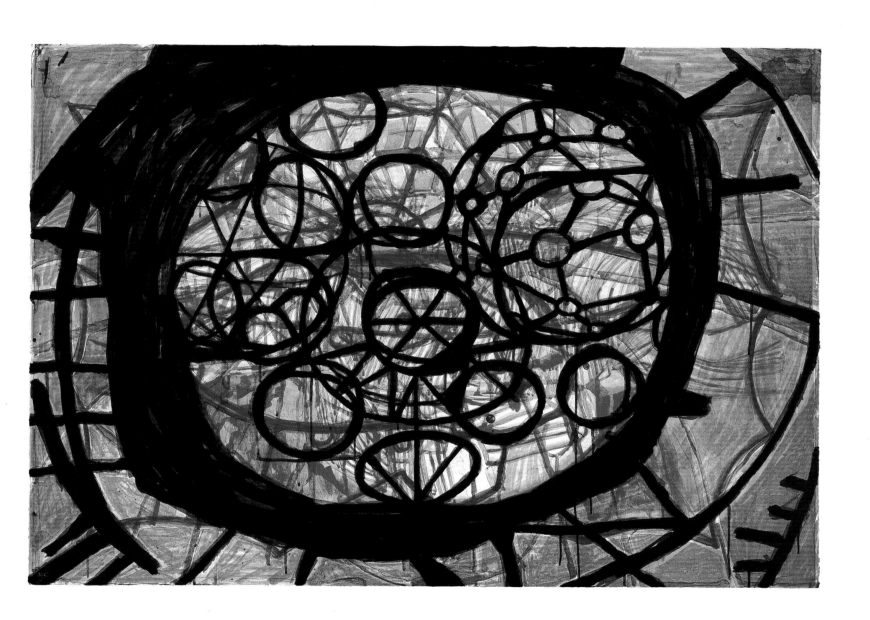

120. Picture Cell 1997

Etching and sugar lift aquatint printed in one color
on Arches En Tout Cas paper (torn to size)
Plate: 86.4 x 108.6 cm (34 x 42 ³/₄ in.)
Sheet: 106.6 x 127 cm (42 x 50 in.)
Signed (*Terry Winters*) and dated (*1997*), upper right
Numbered, upper left
Publisher's drystamp, upper left corner

Edition: 18 plus 7 AP, 4 PP
Proofs: 1 BAT, 1 WP, 1 TP
Printers: Lorena Salcedo-Watson, Jihong Shi,
Bruce Wankel, Craig Zammiello
Publisher: ULAE

Color: Black

Printing sequence: One printing from one plate printed
on an etching press.
Plate preserved for future consideration by the artist.

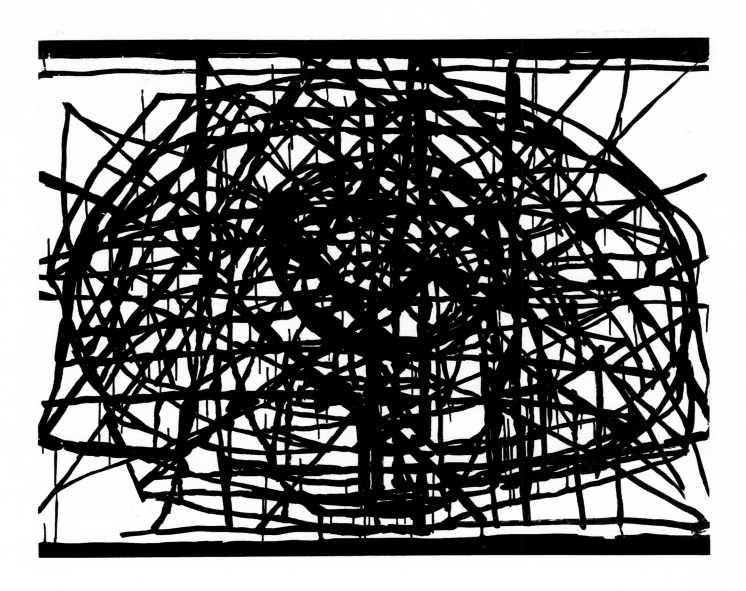

121. Developmental Surface Model 1997
Etching, sugar lift aquatint, and spit bite aquatint
printed in one color on Arches En Tout Cas paper
(torn to size)
Plate: 86.3 x 108.6 cm (34 x 42 3/4 in.)
Sheet (irregular): 106.6 x 127 cm (42 x 50 in.)
Signed (*Terry Winters*) and dated (*1997*), upper right
Numbered, upper left
Publisher's drystamp, upper left corner

Edition: 18 plus 7 AP, 5 PP
Proofs: 1 BAT, 1 WP, 2 TP
Printers: Lorena Salcedo-Watson, Jihong Shi, Scott
Smith, Douglas Volle, Craig Zammiello
Publisher: ULAE

Color: Black

Printing sequence: One printing from one plate printed
on an etching press.
Plate preserved for future consideration by the artist.

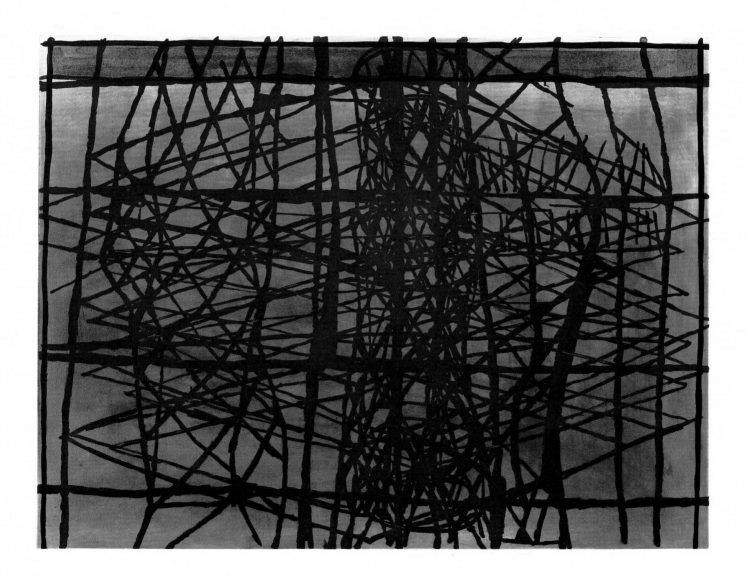

122. Face Boundary 1997

Etching and sugar lift aquatint printed in one color
on Arches En Tout Cas paper (torn to size)
Plate: 86.4 x 108.6 cm (34 x 42 ³/₄ in.)
Sheet: 106.7 x 127 cm (42 x 50 in.)
Signed (*Terry Winters*) and dated (*1997*), upper right
Numbered, upper left
Publisher's drystamp, upper left corner

Edition: 18 plus 7 AP, 3 PP
Proofs: 1 BAT, 1 WP, 1 TP
Printers: Lorena Salcedo-Watson, Scott Smith,
Craig Zammiello
Publisher: ULAE

Color: Black

Printing sequence: One printing from one plate
printed on an etching press.
Plate preserved for future consideration by the artist.

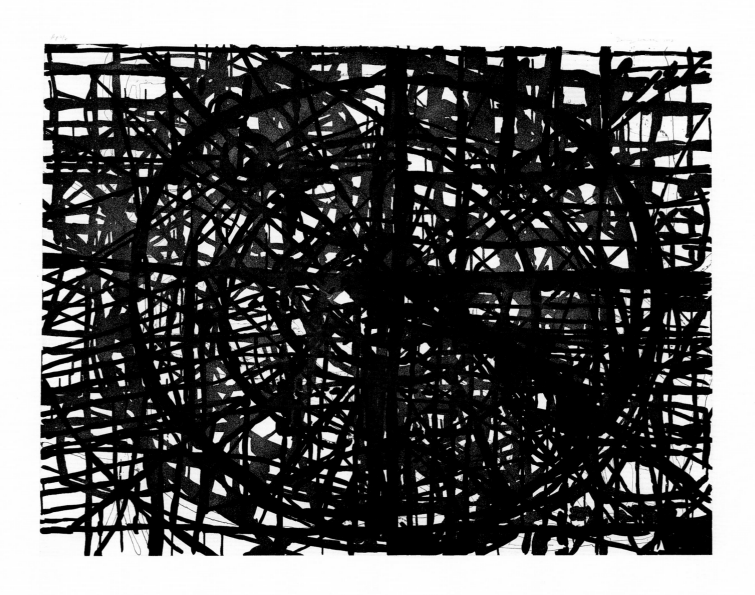

123–131. Graphic Primitives 1998
Portfolio of nine woodcuts printed in one color on
Japanese Kochi paper rinsed with ink
Blocks: 45.7 x 60.9 cm (18 x 24 in.)
Sheets (irregular): 50.8 x 66 cm (20 x 26 in.)
Signed (*Terry Winters*) and dated (*1998*) in white
pencil, lower right of each sheet
Edition numbered in white pencil, lower left of
each sheet
Inscribed in Arabic numerals in white pencil, upper
right of each sheet

Edition: 35 plus 6 AP
Proofs: 1 BAT, 6 TP, 2 unsigned special proofs
printed in white only
Printers: David Lasry, Pedro Barbeito, Guy Corriero
Publisher: Two Palms Press, New York, and
Terry Winters

Colors: White oil paint, black Yasutomo Sumi ink

Printing sequence: Each image printed in white oil
paint from a cherry wood block and wiped with black
Yasutomo Sumi ink. All the blocks cut by a laser
and printed on a hydraulic press. The images are
based on drawings by the artist that were scanned
into a computer and then adjusted.

Issued in a black cloth-covered paperboard folder
(see illustration, this page) made by the Cambell
Logan Bindery, Minneapolis.
Blocks preserved for future consideration by the artist.

GRAPHIC PRIMITIVES

TERRY WINTERS

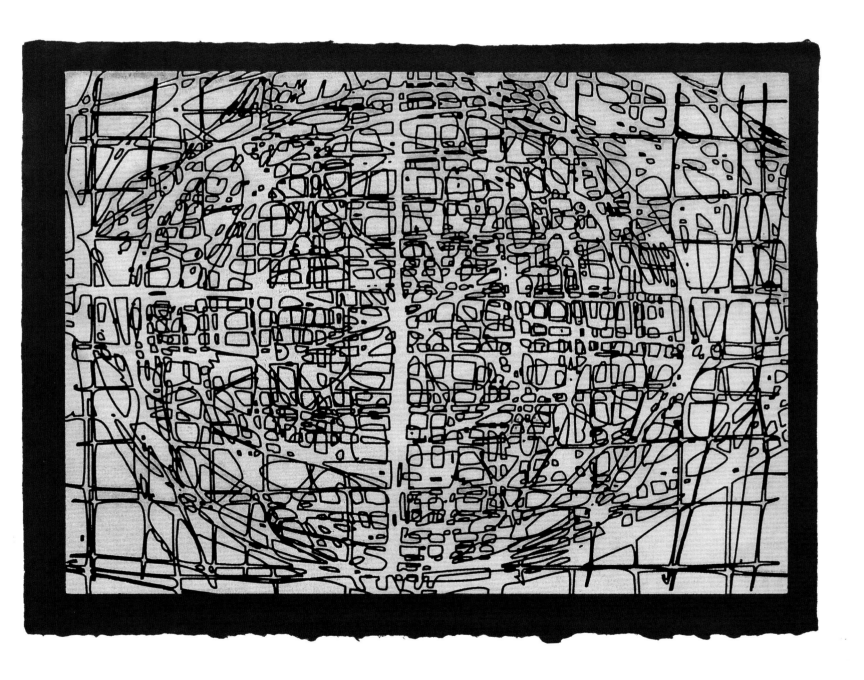

124. Graphic Primitives, 2

Inscribed, upper right: 2

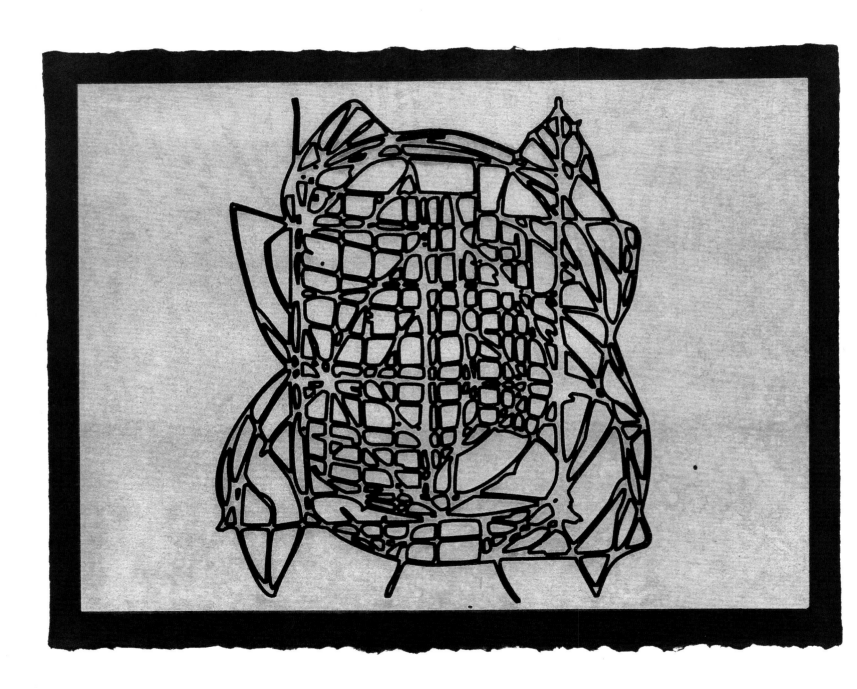

125. Graphic Primitives, 3

Inscribed, upper right: *3*

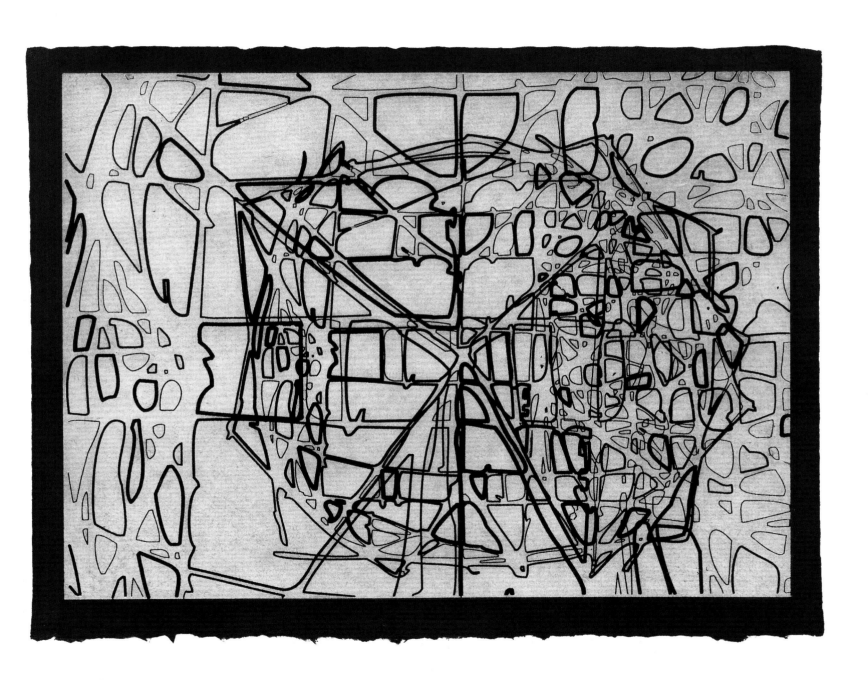

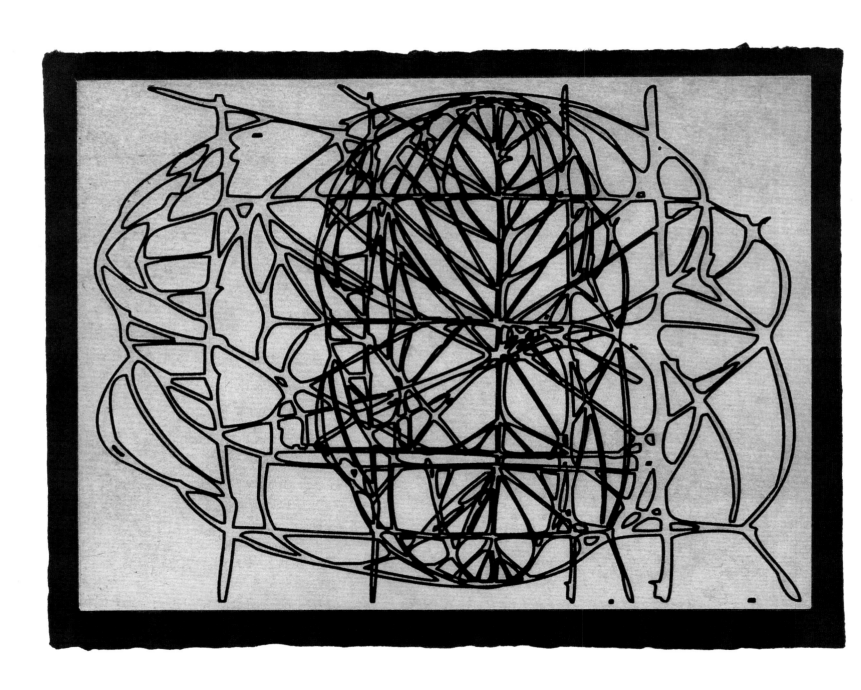

127. Graphic Primitives, 5
Inscribed, upper right: *5*

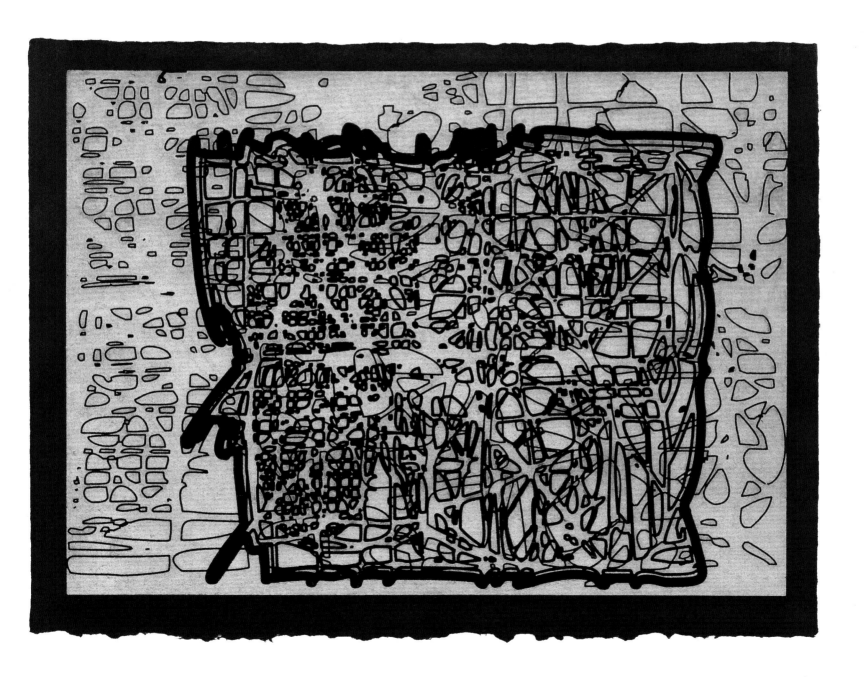

128. Graphic Primitives, 6

Inscribed, upper right: 6

129. Graphic Primitives, 7

Inscribed, upper right: *7*

130. Graphic Primitives, 8

Inscribed, upper right: *8*

131. Graphic Primitives, 9

Inscribed, upper right: 9

132. Internal and External Values 1998
Sugar lift aquatint and open bite etching printed in
one color on Arches En Tout Cas paper (torn to size)
Plate: 85.1 x 108 cm (33 1/2 x 42 1/2 in.)
Sheet: 106.7 x 126.4 cm (42 x 49 3/4 in.)
Signed (*Terry Winters*) and dated (*1998*), lower right
Numbered, lower left
Publisher's drystamp, lower left

Edition: 35 plus 9 AP, 3 PP
Proofs: 1 BAT, 3 TP, 6 state proofs
Printers: Lorena Salcedo-Watson, Jihong Shi,
Craig Zammiello
Publisher: ULAE

Color: Blue

Printing sequence: One printing from one plate
printed on an etching press.
Plate preserved for future consideration by the artist.

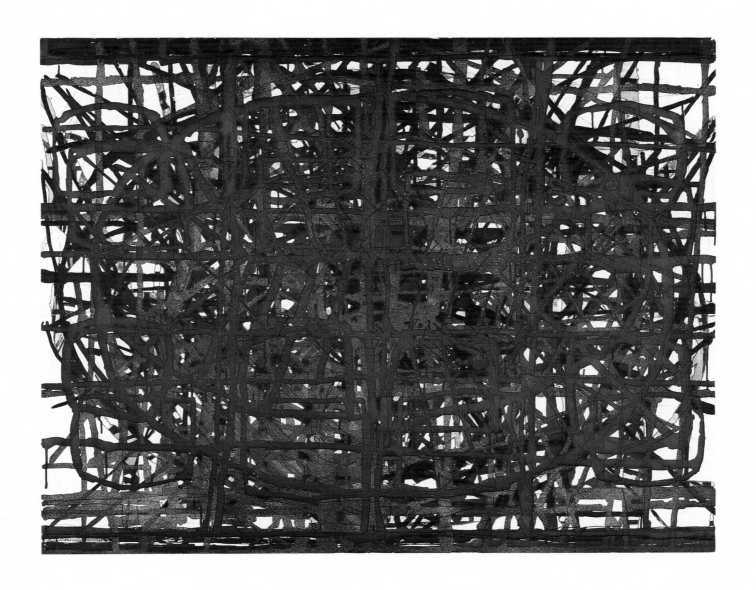

133. Rhizome 1998
Linoleum cut printed in one color
on Kurotani Kozo paper
Block: 45.4 x 60.4 cm (17 $^7/_8$ x 23 $^3/_4$ in.)
Sheet (irregular): 48.2 x 63.5 cm (19 x 25 in.)
Signed (*Terry Winters*) and dated (*1998*), lower right
Numbered, lower left

Edition: 30 plus 5 AP, 4 PP, 6 HC
on Kozo Misumi paper
Proofs: 1 BAT
Printer: Leslie Miller
Publisher: The Grenfell Press, New York

Color: Black

Printing sequence: Printed in one color from one block
on a Vandercook relief proofing press.
Project still in progress.

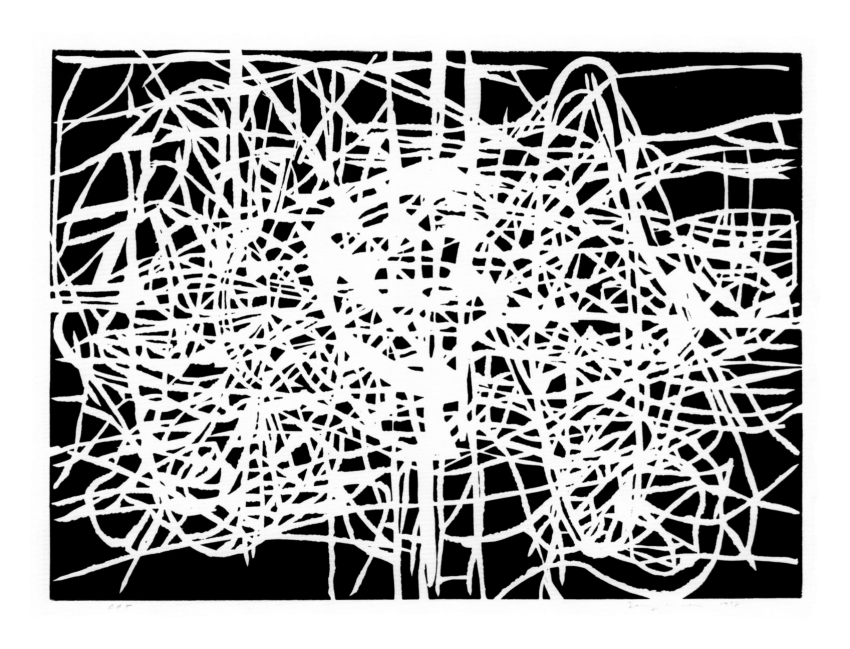

134–143. Set of Ten 1998
Portfolio of ten intaglio prints combining Xerox
transfer, open bite etching, spit bite aquatint, and
sugar lift aquatint printed in one color on paper
handmade in England
Plates: 34.9 x 27.7 cm (13 3/4 x 10 7/8 in.)
Sheets: 45.7 x 38.1 cm (18 3/4 x 15 in.)
Signed and dated (*TW 98*), lower right of each sheet
Numbered, lower left of each sheet
Inscribed, upper right corner of each sheet
Publisher's drystamp, lower left corner of each sheet

Edition: 38, plus 9 AP, 3 PP
Proofs: 1 BAT (signed and dated 1996), 1 TP,
plus various additional proofs listed accordingly
for the individual prints
Printers: Doug Bennett, Jihong Shi, Craig Zammiello
Publisher: ULAE

Color: Black

Printing sequence: Each print made in one printing
from one plate on an etching press.
Project still in progress.

Note: Portfolio accompanied by bound book entitled
Perfection, Way, Origin by Jean Starobinski.

Inscribed, upper right corner: *1 of 10*
Proofs: 2 WP, 9 initialed state proofs

Inscribed, upper right corner: *2 of 10*
Proofs: 7 state proofs (1 with ink additions, inscribed
WP; 1 signed [*TWinters*]; 5 initialed)

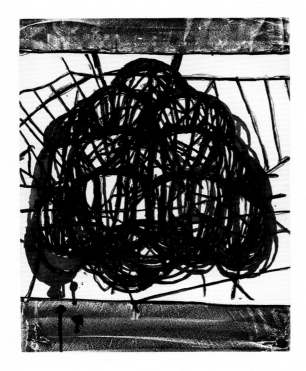

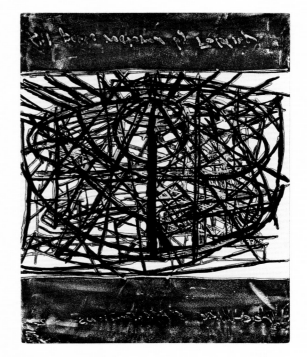

136. 3 of 10
Inscribed, upper right corner: *3 of 10*
Proofs: 1 TP, 4 initialed state proofs

137. 4 of 10
Inscribed, upper right corner: *4 of 10*
Proofs: 1 WP, 5 initialed state proofs

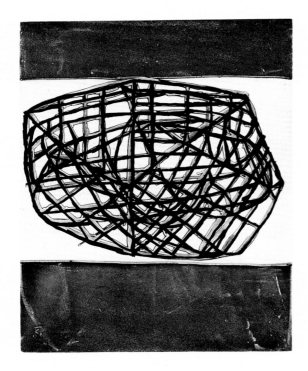

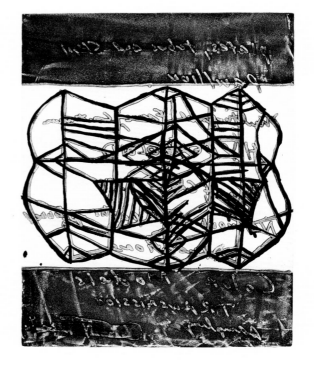

138. 5 of 10
Inscribed, upper right corner: *5 of 10*
Proofs: 6 initialed state proofs

139. 6 of 10
Inscribed, upper right corner: *6 of 10*
Proofs: 6 initialed state proofs (states 4 and 5 have
ink additions and are inscribed: *WP*)

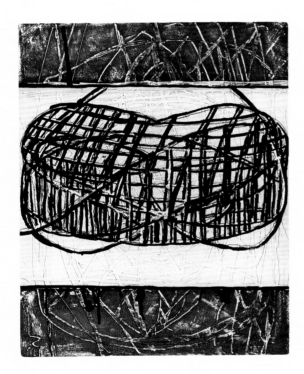

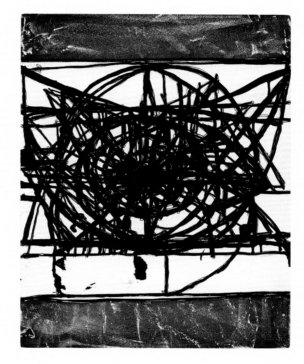

140. 7 of 10
Inscribed, upper right corner: *7 of 10*
Proofs: 7 initialed state proofs (states 4 and 5 have ink
additions and are inscribed: *WP*)

141. 8 of 10
Inscribed, upper right corner: *8 of 10*
Proofs: 8 initialed state proofs

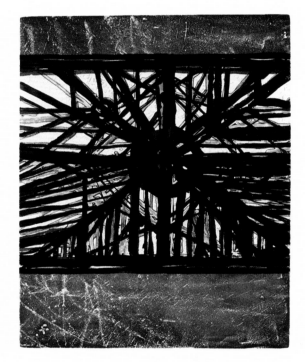

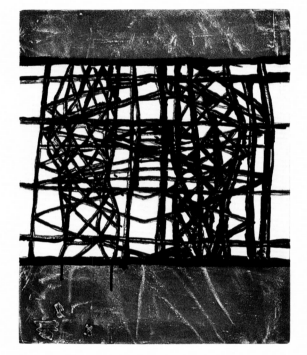

142. 9 of 10
Inscribed, upper right corner: *9 of 10*
Proofs: 5 initialed state proofs

143. 10 of 10
Inscribed, upper right corner: *10 of 10*
Proofs: 8 initialed state proofs

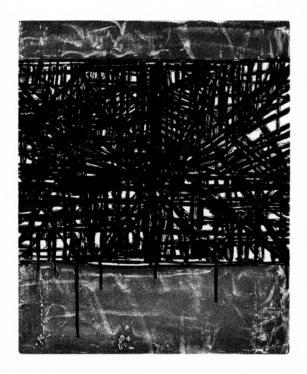

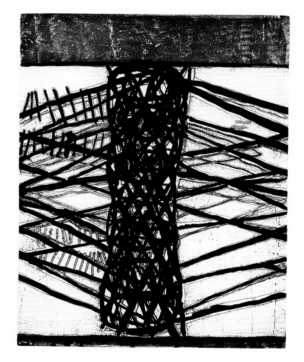

144. Multiple Visualization Technique 1998
Sugar lift aquatint and open bite etching printed in
four colors on Arches En Tout Cas paper (torn to size)
Plate: 111.1 x 85.6 cm (43 3/4 x 33 3/4 in.)
Sheet: 134.6 x 109.2 cm (53 x 43 in.)
Signed (*Terry Winters*) and dated (*1998*), lower right
Numbered, lower left
Publisher's drystamp, lower left corner

Edition: 41 plus 9 AP, 2 PP
Proofs: 1 BAT, 1 TP
Printers: Jihong Shi, Craig Zammiello
Publisher: ULAE

Colors: Yellow, blue, red, black

Printing sequence: Four printings from four plates
on an etching press.
1) yellow 2) blue 3) red 4) black

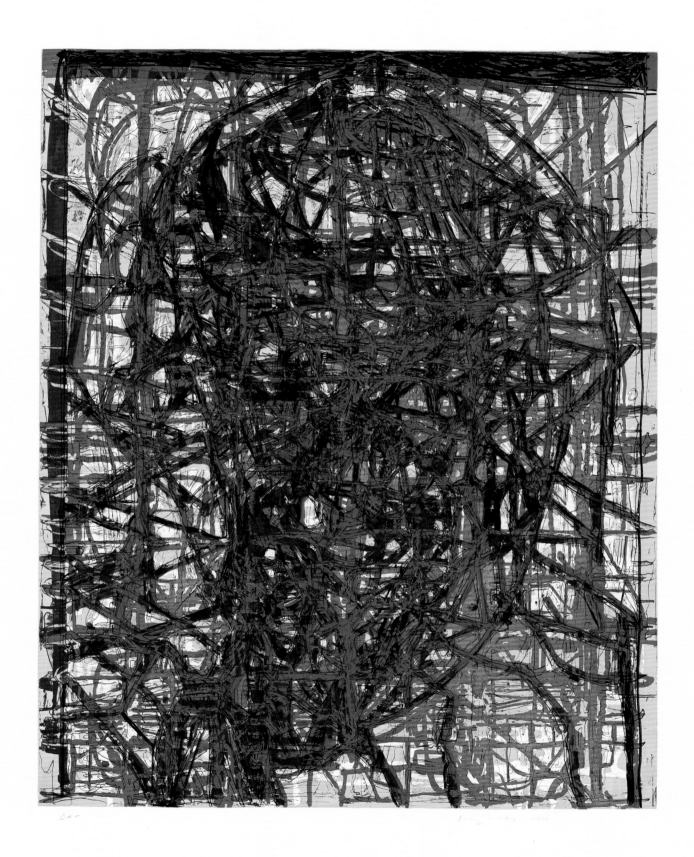

Terry Winters, 1991
Photograph by Nan Goldin

Selected Bibliography

Books and Exhibition Catalogues

Boston, School of the Museum of Fine Arts. *Terry Winters: Recent Works*. Exh. cat. with essays by Lelia Amalfitano and Raphael Rubinstein. 1997.

Brooklyn Museum. *The American Artist as Printmaker*. Exh. cat. with foreword by Robert T. Buck and text by Barry Walker. 1983.

Brooklyn Museum. *Projects and Portfolios: The 25th National Print Exhibition*. Exh. cat. with foreword by Robert T. Buck and text by Barry Walker. 1989.

Brooklyn Museum. *Public and Private: American Prints Today. The 24th National Print Exhibition*. Exh. cat. with foreword by Robert T. Buck and text by Barry Walker. 1986.

Enright, Robert. *Peregrinations: Conversations with Contemporary Artists*. Winnipeg, 1997.

Fineberg, Jonathan. *Art Since 1940—Strategies of Being*. New York, 1995.

Hamburg, Hamburger Kunsthalle. *Family Values: Amerikanische Kunst der achtziger und neunziger Jahre (American Art in the Eighties and Nineties) — Die Sammlung Scharpff in der Hamburger Kunsthalle (The Scharpff Collection at the Hamburg Kunsthalle)*. Exh. cat. with essays by Stephan Schmidt-Wulffen and Christoph Heinrich in German and English. 1996.

Los Angeles, Margo Leavin Gallery. *Jasper Johns Brice Marden Terry Winters: Drawings*. Exh. cat. with essay by Jeremy Gilbert-Rolfe. 1992.

Lucerne, Kunstmuseum Luzern. *Terry Winters*. Exh. cat. with introduction by Martin Kunz and essay by Klaus Kertess. 1985.

Milwaukee Art Museum. *Terry Winters Drawings. Currents 16*. Exh. cat. by Dean Sobel. 1989.

Minneapolis, Walker Art Center. *First Impressions: Early Prints by Forty-six Contemporary Artists*. Exh. cat. with introduction by Elizabeth Armstrong and essays by Elizabeth Armstrong and Shelia McGuire. 1989.

Munich, Galerie Fred Jahn. *Terry Winters / Fourteen Drawings / Fourteen Etchings*. Exh. cat. by David Shapiro. 1990.

Munich, Galerie Fred Jahn. *Terry Winters: Foundations and Systems. Fünfzig neue Zeichnungen von Terry Winters / Fifty New Drawings by Terry Winters*. Exh. cat. by Michael Semff. 1995.

New Haven, Conn., Yale University Art Gallery. *Reinventing the Emblem: Contemporary Artists Recreate a Renaissance Idea*. Exh. cat. with essays by Allison B. Leader and Richard S. Field. 1995.

New York, Matthew Marks Gallery. *Terry Winters Computation of Chains*. Exh. cat. 1997.

New York, Museum of Modern Art. *Thinking Print: Books to Billboards, 1980-95*. Exh. cat. by Deborah Wye. 1996.

New York, Whitney Museum of American Art. *American Print Renaissance 1958-1988*. Exh. cat. by Roni Feinstein. 1988.

New York, Whitney Museum of American Art. *Terry Winters*. Exh. cat. by Lisa Phillips with essays by Klaus Kertess and Lisa Phillips. 1991.

New York, Whitney Museum of American Art. *Three Printmakers: Jennifer Bartlett, Susan Rothenberg, Terry Winters*. Exh. brochure by Judith Goldman. 1986.

New York, Whitney Museum of American Art at Equitable Center. *Aldo Crommelynck Master Prints with American Artists*. Exh. cat. with essay by Adam D. Weinberg. 1988.

The Paine Webber Art Collection. With foreword by Donald B. Marron, introduction by Jack Flam, and commentaries by Monique Bendert and Jennifer Wells. New York, 1995.

Rohnert Park, Calif., Sonoma State University, Art Gallery, and Northridge, California State University, Art Galleries. *The Monumental Image*. Exh. cat. with introduction and essay by Judith Dunham. 1987.

Santa Barbara, University of California, University Art Museum. *Terry Winters: Painting and Drawing*. Exh. cat. by Phyllis Plous with essay by Christopher Knight. 1987.

Shapiro, David. *After a Lost Original*. New York, 1991.

Tallman, Susan. *The Contemporary Print from Pre-Pop to Postmodern*. London, 1996.

Tokyo, Gallery Mukai. *Terry Winters: Index I-X*. Exh. cat. with essay by Lisa Liebmann. 1989.

Washington, D.C., Corcoran Gallery of Art. *Proof Positive — Forty Years of American Printmaking at ULAE 1957-1997*. Exh. cat. with essays by Jack Cowart, Sue Scott, and Tony Towle. 1997.

Winters, Terry. *Ocular Proofs*. New York, 1996.

Winters, Terry. *Schema*. Text by Roberta Smith. West Islip, New York, 1988.

Periodicals

Ackley, Clifford S. "'Double Standard': The Prints of Terry Winters." *The Print Collector's Newsletter* 18, 4 (September/October 1987): 121-124.

Ackley, Clifford S. "Terry Winters and Cliff Ackley — A Conversation." *Art New England* (June/July 1993): 29-31.

Carlson, Prudence. "Terry Winters' Earthly Anecdotes." *Artforum* 23, 3 (November 1984): 65-68.

Carlson, Prudence. "Terry Winters." *Galleries Magazine* 18 (April/May 1987): 74-79, 125, 128.

Ellis, Stephen. "Metaphorical Morphologies." *Art in America* 76, 9 (September 1988): 150-155.

Gutterman, Scott. "Facts of Life: Terry Winters Describes the Irreducible Nature of Existence — in Paint." *The Journal of Art* 4, 7 (September 1991): 38-40

Kuspit, Donald. "Terry Winters." *Artforum* 34, 3 (November 1995): 88.

Princenthal, Nancy. "Artists Book Beat." *The Print Collector's Newsletter* 27, 2 (May-June 1996): 67-69.

"Prints & Photographs Published." *The Print Collector's Newsletter*
 Ova: vol. 14, no. 1 (March-April 1983): 21.
 Morula I, II, III: vol. 15, no. 1 (March-April 1984): 27.
 Double Standard: vol. 16, no. 1 (March-April 1985): 21.
 Primer: vol. 16, no. 6 (January-February 1986): 218.
 Folio: vol. 17, no. 1 (March-April 1986): 18.
 Untitled: vol. 19, no. 1 (March-April 1988): 21.
 Marginalia: vol. 19, no. 5 (November-December 1988): 193.
 Album: vol. 20, no. 1 (March-April 1989): 22.
 Fourteen Etchings: vol. 21, no. 1 (March-April 1990): 26.

Primitive Segments: vol. 23, no. 1 (March-April 1992): 27.
Field Notes: vol. 23, no. 4 (September-October 1992): 144.
Theorem: vol. 23, no. 6 (January-February 1993): 232.
Models for Synthetic Pictures: vol. 25, no. 6
(January-February 1995): 227.
Untitled: vol. 26, no. 1 (March-April 1995): 21.

"Working Proof." *On Paper: The Journal of Prints, Drawings, and Photographs* 2, 1 (September-October 1997): 37-42.

Newspapers

Temin, Christine. "Winters' Lithographs Escape Trendiness Trap." *The Boston Globe*, May 29, 1986.

Additional References

Books and Exhibition Catalogues

Boston, Mario Diacono Gallery. *Terry Winters*. Exh. brochure by Mario Diacono. 1987.

Chicago, Renaissance Society at the University of Chicago. *The Meditative Surface*. Exh. cat. with essay by Carter Ratcliff. 1984.

Edinburgh, Royal Scottish Academy. *Edinburgh International: Reason and Emotion in Contemporary Art*. Exh. cat. edited by Douglas Hall with essay by Jeremy Lewison. 1988.

London, Saatchi Gallery. *Young Americans 2: New American Art at the Saatchi Gallery*. Exh. cat. by Brooks Adams and Lisa Liebmann. 1998.

London, Tate Gallery. *New Art at the Tate Gallery 1983*. Exh. cat. by Michael Compton. 1983.

London, Tate Gallery. *Terry Winters — Eight Paintings*. Exh. cat. with essay by Jeremy Lewison. 1986.

Los Angeles, Museum of Contemporary Art. *The Barry Lowen Collection*. Exh. cat. with essay by Christopher Knight. 1986.

Madrid, Museo Nacional Centro de Arte Reina Sofía. *Nuevas Abstracciones*. Exh. cat. with essays by Arthur C. Danto, Enrique Juncosa, and Demetrio Paparoni. 1996.

Milwaukee Art Museum. *25 Americans: Painting in the 90s*. Exh. cat. by Dean Sobel. 1995.

Munich, Bayerische Staatsgemäldesammlungen, Staatsgalerie Moderner Kunst München. *Sieben Amerikanische Maler*. Exh. cat. by Carla Schulz-Hoffman in German and English. 1991.

Munich, Staatliche Graphische Sammlung München. *Von Baselitz Bis Winters! Vermächtnis Bernd Mittelsten Scheid*. Exh. cat. by Michael Semff with essays by Michael Semff and Brita Sachs. 1998.

New York, Museum of Modern Art. *Allegories of Modernism — Contemporary Drawing*. Exh. cat. by Bernice Rose. 1992.

New York, Whitney Museum of American Art. *Art in Place: Fifteen Years of Acquisitions*. Exh. cat. by Tom Armstrong and Susan C. Larsen. 1989.

New York, Whitney Museum of American Art. *1985 Biennial Exhibition, Whitney Museum of American Art, New York*. 1985.

New York, Whitney Museum of American Art. *1987 Biennial Exhibition, Whitney Museum of American Art, New York*. 1987.

New York, Whitney Museum of American Art. *Views From Abroad: European Perspectives on American Art 3/American Realities*. Exh. cat. by Nicholas Serota, Sandy Nairne, and Adam D. Weinberg. 1997.

New York, Whitney Museum of American Art. *Vital Signs-Organic Abstraction from the Permanent Collection*. Exh. cat. by Lisa Phillips. 1988.

New York, Museum for African Art. *Western Artists / African Art*. Exh. cat. by Daniel Shapiro with essay by Jack Flam. 1994.

Overland Park, Kansas, Johnson County Community College Gallery of Art. *Terry Winters*. Exh. brochure by Jerry Saltz. 1994.

Rose, Barbara. *American Painting, the Twentieth Century*. Geneva, 1986.

Saint Louis Art Museum. *Terry Winters. Currents 33.* Exh. brochure by Marie Louise Kane. 1987.

Sarasota, Fla., John and Mable Ringling Museum of Art. *Abstraction in Question: An Exhibition of the John and Mable Ringling Museum of Art.* Exh. cat. with essays by Bruce Ferguson, Joan Simon, and Roberta Smith. 1989.

Tokyo, Wacoal Art Center. *Vernacular Abstraction.* Exh. cat. with essay by Roberta Smith. 1985.

Vienna, Graphische Sammlung Albertina. *Amerikanische Zeichnungen in den achtziger Jahren.* Exh. cat. with essay by Roberta Smith in German and English. 1990.

Washington, D.C., Corcoran Gallery of Art. *The Fortieth Biennial Exhibition of Contemporary American Painting.* 1987.

Periodicals

Adams, Brooks. "Terry Winters at Sonnabend." *Art in America* 82, 10 (October 1994): 130-131.

Anfam, David. "New York: Winters, Wegman, de Kooning and Tansey." *The Burlington Magazine* 134 (July 1992): 466-467.

Cooke, Lynne. "Terry Winters' Poetic Conceits." *Artscribe International* 59 (September/October 1986): 62-64.

Hughes, Robert. "Obliquely Addressing Nature." *Time* 127, 8 (February 24, 1986): 83.

Liebmann, Lisa. "Terry Winters, Sonnabend Gallery." *Artforum* 21, 6 (February 1983): 72.

Rubenstein, Raphael. "Nine Lives of Painting." *Art in America* 86, 9 (September 1998): 90-99.

Saltz, Jerry. "The Embryonic Vision: Terry Winters' *The Psychological Corporation,* 1990." *Arts Magazine* 66, 5 (January 1992): 21-2.

Winters, Terry. "Terry Winters 6 — Field Sequence." *Sulfur* 39 (Fall 1996): 68-75.

Newspapers

Baker, Kenneth. "10 Years of Terry Winters: Retrospective at L.A.'s MOCA." *The San Francisco Chronicle*, October 27, 1991.

Baker, Kenneth. "Terry Winters: Drawing and Painting." *The San Francisco Chronicle*, January 24, 1988.

Cotter, Holland. "Terry Winters Drawings." *The New York Times*, May 12, 1995.

Kimmelman, Michael. "Cells, Crystals, Bugs and Shells, Rendered in Paint." *The New York Times*, March 8, 1992.

Kimmelman, Michael. "Terry Winters." *The New York Times*, October 31, 1997.

Knight, Christopher. "Winters' Growth: Sensual Fusion of Culture and Nature." *The Los Angeles Times*, September 18, 1991.

Schjeldahl, Peter. "The Redeemer." *The Village Voice*, October 28, 1997.

Wallach, Amei. "Picturing the Painting Process." *Newsday*, February 28, 1986.

Photo Credits

All photographs courtesy of ULAE except the following:
Primitive Segments, Glyphs, Rhizome, and *Graphic Primitives*
— James Dee
Untitled (1988), *Album,* and *Field Notes*—Steven Sloman
Pieter van de Venne, *Still Life with Shells and Insects*
— The Detroit Institute of Arts
Pierre-Antoine Poiteau, *Pommier de Montalivet* and John James
Audubon, *Whooping Crane*—Kenyon-Oppenheimer, Inc., Chicago

Index

DATE DUE		
MAR 8 0 2002	DEC 3 1 2005	
MAY 8 2002	MAY 0 4 2007	
	OCT 0 2 2007	
OCT 1 7 2002		
NOV 1 1 2002	OCT 0 8 2007	
FEB 1 7 2003	NOV 0 4 2007	
OCT 0 7 2003		
OCT 2 4 2003	NOV 0 5 2007	
FEB 2 8 2004	NOV 2 0 2007	DEC 3 1 2008
MAY 0 5 2004		
OCT 2 4 2004	5/3/12	
DEC 0 6 2004		
FEB 1 0 2005		
MAR 3 2005		
DEC 0 7 2006		
	FEB 2 2 2007	
GAYLORD	FEB 1 0 2008	PRINTED IN U.S.A.